IMAGES
of America

FORT PIERCE

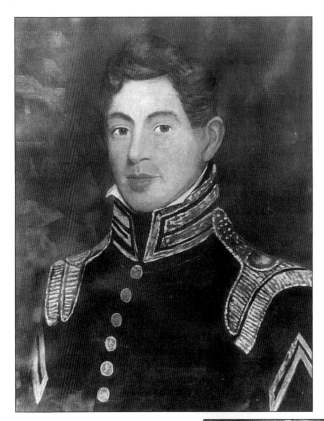

This is a portrait of Col. B.K. Pierce, commanding officer, for whom the fort was named during the Seminole Wars. The name Fort Pierce was chosen by the early pioneers for their newly incorporated city in 1901. It became the county seat of Saint Lucie County, created by the Florida State Legislature in 1905.

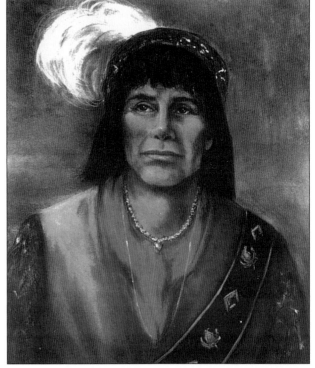

Bill Summerlin portrayed the Seminole Chief Wild Cat who came to the fort to try to arrange a peace with Colonel Pierce that would allow the Seminoles to remain here and be given designated lands for their homes. Colonel Pierce regretfully had to refuse, for President Jackson had ordered that all Indians had to be removed from the peninsula. Bill Summerlin is in the costume he wore when he portrayed Seminole War Chief Wild Cat in the fort scene of the historical outdoor drama.

IMAGES
of America

FORT PIERCE

Ada Coats Williams

ARCADIA

Published by Arcadia Publishing
an imprint of Tempus Publishing Inc.
Charleston SC, Chicago, Portsmouth NH, San Francisco

Printed in Great Britain

Library of Congress Catalog Card Number: 2003103938

For all general information contact Arcadia Publishing at:
Telephone 843-853-2070
Fax 843-853-0044
E-mail sales@arcadiapublishing.com
For customer service and orders:
Toll-Free 1-888-313-2665

Visit us on the internet at http://www.arcadiapublishing.com

CONTENTS

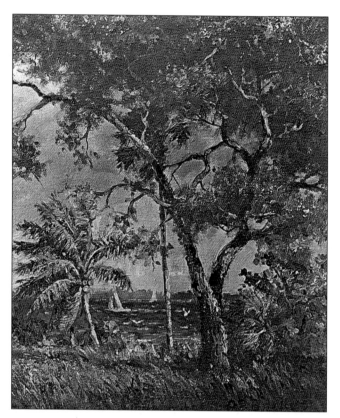

This is a scene of the Indian River painted by A.E. "Bean" Backus, an internationally famous landscape artist of the pioneer Backus family. This scene was requested for the program cover of the 1976 United States Bicentennial production of the historical outdoor drama *Along These Waters*. This body of water, named by the Spanish explorers, is not a river. It looks like a river because islands, reaching for 150 miles south of Titusville, separate it from the Atlantic Ocean, except for two natural inlets: one north of Fort Pierce, which fronts the water, and one at Jupiter near the end of the islands. It is a salt water estuary with tides, not a river with a beginning and flowing in one direction.

ACKNOWLEDGMENTS

I express gratitude to many who have helped to prepare this pictorial history of my bit of America—Fort Pierce, Florida: Iva Jean Maddox, superintendent of the Saint Lucie County Historical Museum; Leon "Jim" Heffelfinger, Museum Photographic Curator; Dorothy Roberts, Museum Supervisor; Anne Sinnott, Museum Education Director; Sue Owens, Coordinator of Office Skills Technology, and the instructors and assistants in her program at Indian River Community College, who gave great computer assistance; and the descendants of many of the early pioneer families, have all contributed their time, research, photographs, and knowledge to aid in this publication.

I dedicate this book to my pioneer parents, William Lee and Katie Turner Coats, who gave me this lovely place in which to live and grow, and who inspired me to appreciate this community by their pride in its growth, and their dedication to its educational, cultural, and spiritual environment.

INTRODUCTION

The Florida peninsula, discovered by Ponce De Leon in 1512, became the first frontier of our nation, and later became its last frontier for settlement. Five different flags have flown over this state for five different governments: Spain, England, a small portion for France, Spain again, United States, Confederate, and finally the United States.

President Jackson, a former territorial governor of Florida, was anxious to get the peninsula settled. He believed that if the Indians were removed, settlers would come. He attempted to bribe them to move to Oklahoma. Few moved, the rest remained and fought in the United States-Seminole wars, attempting to keep this land that had been theirs. Many were killed, a number were captured and sent out to Oklahoma, and a few, approximately 150, fled to the Keys and the Everglades. It was customary to name the U.S. forts for the commanding officer. The fort established on the Indian River Lagoon in 1837 was named Fort Pierce for its commanding officer, Col. Benjamin K. Pierce.

To encourage settlement, Congress passed the Armed Occupation Act in 1842, which provided two ships, one for the East Coast and one for the West Coast of Florida, to bring men who could homestead 160 acres of land if they stayed on it for seven years. The Indians slowly returned to the area, and the venture failed because one who established a trading post was killed by the Indians who found that he had been cheating them. The Indians warned the others to leave, and the homesteaders all boarded the ship and sailed up to Saint Augustine, having spent only four years on their land. Once again, the area remained a tropical wilderness with only the Indians to enjoy the climate, the beautiful waters filled with fish, oysters, and clams, as well as the land rich with deer, turkeys, and bear for meat.

In the 1860s and 1870s, individual families began coming and homesteading near the location of the old fort where there was a fresh water spring. None were sponsored by the government, and all remained to develop a community that became the county seat of Saint Lucie County, named Fort Pierce. It seemed as if the time had come on God's calendar for this beautiful land to be settled.

Five main types of businesses developed: fishing, cattle, pineapples, vegetables, and citrus. These businesses, except for the pineapple industry (that ended because of the competition from the Cubans), are still thriving.

Fort Pierce has retained its former small-town friendliness, and has cultural and educational facilities such as the Opera Society and Indian River Community College. Locally classes are available from Florida Atlantic University and the University of Florida. There are also the

Saint Lucie County Museum, the World War II Underwater Demolition Team Seal Museum, the Smithsonian Institute, Harbor Branch Oceanographic Institute, numerous branches of the public library, The Indian River Choral and Orchestra, the Pineapple Playhouse Community Theater, and college musical and stage productions.

Many settlers and tourists are attracted to the area because of the climate; the numerous beautiful waterways for fishing, swimming, surfing, sailing, and boating; and the interesting cultural environment. One of the early pioneers, Harry Hill, established the first photographic business in the state. His pictures are used in this pictorial history of Fort Pierce. Many persons are now discovering this tropical Eden and are joining with the descendants of the first pioneers as proud citizens of Fort Pierce, Florida.

One
NATIVE INHABITANTS

The first people who lived along the waters of the Indian River Lagoon and the vast ocean to the east, the Atlantic, were the Ais Indians, believed to be one of the tribes that crossed the land bridge, formerly existing between Siberia and Alaska. As they spread out over this continent, 12 tribes settled on the peninsula of Florida, and were estimated to number about 25,000. The numbers diminished drastically after the European invasions. Many died from European diseases, many were killed in wars as the Europeans claimed the land, and others were carried off to be sold as slaves.

In the 1700s, the Creek nation of Indians, who lived in the areas now known as Georgia and Alabama, split. Many came to Florida, driven by Europeans who claimed the Creeks's territory. While the Ais Indians were primitive and now numbered approximately only 200, the Creeks were considered one of the five highly civilized tribes, with one of the highest moral codes known. They lived in log cabins, and had strict rules about how men were to speak to and treat women and children. These people became known as the Seminoles. Today their language still reflects their moral code: the Seminole language contains no obscenities and no profanity. If these so-called "savages" wished to use such language, they would have had to use the language of the "civilized" nations: England, Spain, or France. These were the native people that the government once tried to remove to encourage settlement.

The permanent pioneers lived in peace with the Seminoles, who taught the settlers to use the native plants for food and medicine, to treat burns and insect bites with the aloe plant, and to remove the heart of the sabal palm to eat raw or cooked with meat for a healthful vegetable.

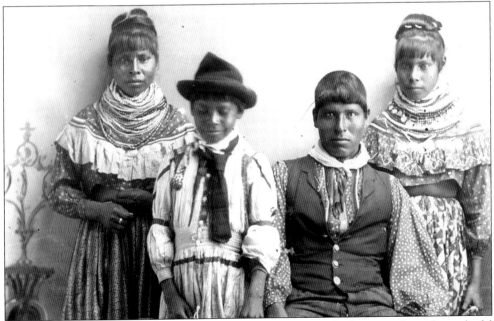

When the Seminoles came to Fort Pierce to shop or to sell goods, they were dressed in colorful fashions and adults and children were always barefoot. The ladies and girls wore many strands of beads that had been given to them for special occasions or as rewards for special actions.

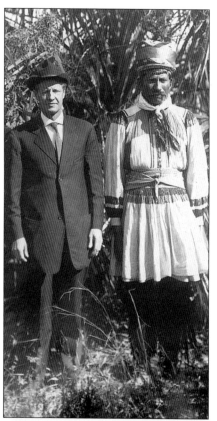

Pioneer Dick Robinson stands with Seminole Billy Bowlegs III, a man of both Native American and European American decent, who could speak English and who had learned minimal reading skills. As an adult, he had many friends among the white men. He was invited to appear at many Florida celebrations, and after his death at 100 years or more of age, his home became a popular destination for Seminole children to learn the culture of their ancestors.

The first Seminole children to enter Fort Pierce schools were the children of Willie and Flora Jones. They portrayed their people in the historical outdoor drama *Along These Waters*. Each child graduated from high school and attended Indian River Community College. The youngest, Louise, was the first Seminole woman in the history of her nation to earn a four-year college degree. She is a graduate of Indian River Community College and Florida Atlantic University. Pictured from left to right are Louise; an unidentified cousin; mother Flora; daughter Addie; and son Bert. Seminole children are of their mother's clan; Flora was of the Panther Clan, the clan to which one must belong to qualify to be chosen a chief and medicine man. As an adult Bert was chosen to serve as chief and medicine man of the Brighten Indian Reservation.

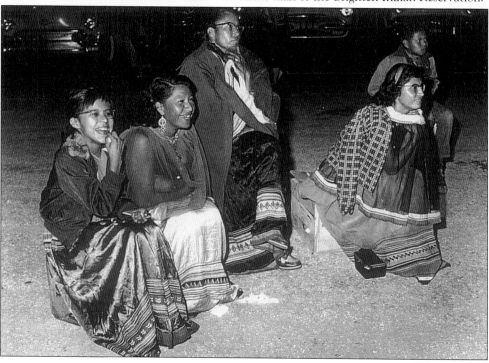

Louise Jones Gopher and Addie Jones Osceola visit with author Ada Williams at a book signing of *Florida's Ashley Gang*. The Jones children grew up on the Williams home property in order to be near a bus stop when they entered the Fort Pierce school. The book was dedicated to them, their brother Bert, and their mother. Their mother's father, DeSota Tiger, a main character in *Florida's Ashley Gang*, had been killed by John Ashley, a man who had stolen the Indian hunters' hides and furs and gathered them to sell to Girtman Bros. in Miami. John Ashley later became a hunted criminal and formed a notorious gang that terrified much of Florida. He and his gang were eventually caught and killed on the Sebastian Bridge in November 1924. Addie works with the children on the Brighton Indian Reservation, and Louise is an Education Director for many reservations.

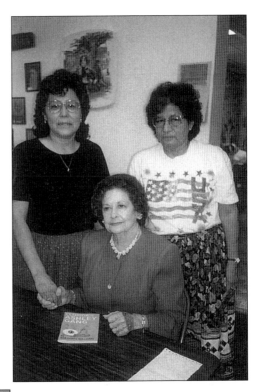

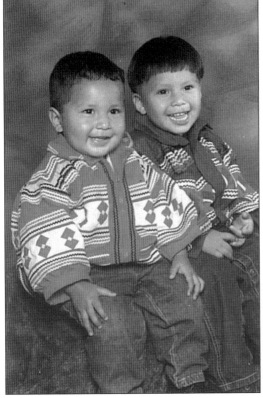

These happy Indian children are the grandsons of Louise Jones Gopher: Eric Desoto Tiger Garcia, age 1; and Michael Jeffrey Garcia, age 2, as of March 2000. They are of the Panther Clan, and some day will be eligible to be chosen Chief and Medicine Man.

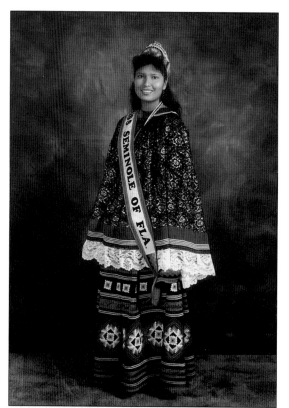

Rita Gopher, daughter of Louise Jones Gopher, like her mother is a college graduate. She followed her mother in being elected "Miss Seminole of Florida" to represent the Florida Seminoles at local and national conventions and celebrations. Later her college student sister, Carla, and her cousin Abbey, daughter of Addie Osceola, were each elected to this honor.

When Florida was inhabited by only Indians, they placed their dead in an enclosed litter made of palm fronds, storing them up in the branches of a tree. As the area received settlers, the natives started to place their dead in boxes in wooded areas. This is one such burial where the family discovered that the box had been damaged, possibly by animals or by outlaws hoping to find treasures buried with the deceased owner.

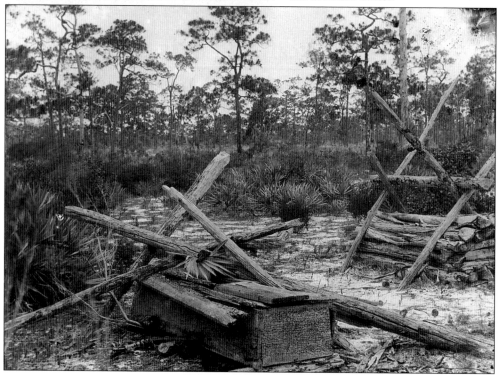

Two

EARLY PIONEERS

The first pioneers who came to this area had no access to city or county governments, for it was a part of Brevard County with the county seat far up the coast at Titusville. There were no roads, railway, electricity, or telephones, and the area contained no schools, churches, or doctors.

The first five families were the families of Carlton, Hendry, Paine, Bell, and Hogg. The Carltons had nine children and brought a teacher to live with them to teach the children. The family invited the children of the other families to join in the studies.

The Carltons also brought the first cattle to the area, and their descendants are still cattlemen.

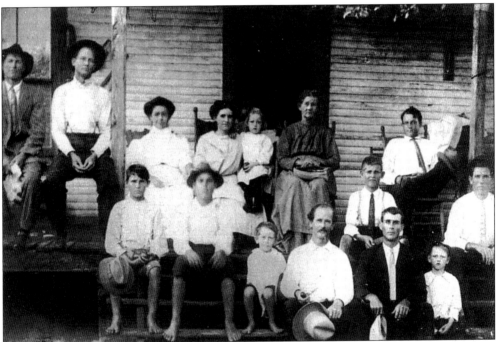

Appearing in this picture of the Reuben Carlton family are (from left to right) as follows: (front row) unidentified boy, Fate Williams, Thad Carlton, Charles Carlton, Dan Carlton, and Dan Jr. "Squeeks" Carlton; (back row) R. Carlton, Wright Carlton, Teresa, wife of Dan; Louise Carlton Whitice, daughter Louise; mother, Elizabeth Crews Carlton; and unidentified neighbor. The sons of this family (Wright, Lyn, Charles, Dan, and Perry) and daughters (Sally and Louise) all remained in Fort Pierce to establish their cattle and citrus businesses. It was custom to brand a calf for each child at birth, and brand one each birthday thereafter until adulthood. Each child then had a herd of cattle that was already breeding, and ready for each child's ranch. Some of the land owned by the descendants of this pioneer family was the land first owned by their pioneer ancestors, one of the first five families to settle here.

13

When the City of Fort Pierce was incorporated in 1901, Dan Carlton was appointed City Marshall. After Saint Lucie County was created in 1905, he was the first elected County Sheriff in 1907. He was killed in an ambush by a presumed hired killer from out of town in 1913.

HON. D. S. CARLTON

Boat Capt. Benjamin Hogg courted and married Annie Jessie Kincaid Donelson Yorkston of the Royal House of York in Scotland. For marrying a commoner, her royal parents disinherited her. Annie and her husband came to America and settled in this area. Annie sold her royal jewels to purchase a schooner for her husband. On Captain Hogg's first big deal, he bought Annie a $100 gold watch on a gold chain as a gift for the jewels she had sold to buy his boat. Annie Hogg was the first business woman in the area. She opened a small trading post at the location of the old United States Fort Pierce. Later, she purchased a lot by the river from R. Carlton's wife, Elizabeth, for a larger store, closer to the customers' homes.

Capt. Benjamin Hogg, who had captured
the heart of a beautiful royal lady, sailed up
the coast to South Carolina and down to
the islands below the Florida peninsula,
selling produce and goods, and buying goods
for their new store.

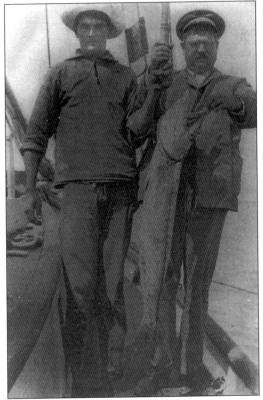

After President Theodore Roosevelt
created the first wildlife preserve at
Pelican Island in Florida, in 1903, he was
carried to the dedication ceremony at the
preserve by the boat of Captain Hogg. The
president enjoyed his ride, and he
especially enjoyed fishing in the Indian
River. This is a picture of the president
with one of Hogg's crew, proudly holding
his catch for a photograph.

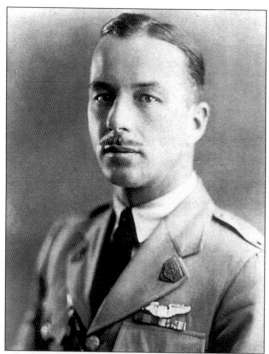

World War I Flying Ace Francis Benjamin Tyndall was the grandson of Benjamin and Annie Hogg. He was killed in an accident, and the United States Tyndall Air Force Base is named for him. .

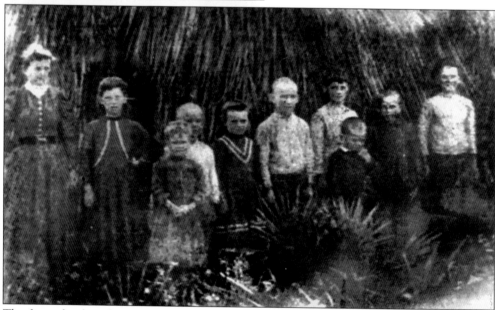

The first school in the area was a one-room building thatched with palm fronds, and located between Fort Pierce and Saint Lucie (now Saint Lucie Village). The areas were combined because there were not enough children in either place for the state to hire two teachers. The children walked to school, and all grades met together. The children carried lunch in tin buckets, and drank water by dipping a hollowed-out gourd in a bucket of water, all using the same gourd. On cold days, the children carried blankets to school to be used for warmth as they sat outdoors around a camp fire. An iron wood-burning stove could not be used in the school for warmth for fear that the heat from the stove pipe would have set the roof on fire.

Alexander Bell, one of the first five pioneers to come to this area, left his home and large plantation in Jasper in 1871 because he was ostracized by the community for not fighting for the Confederacy in the Civil War. Alexander went to another part of the state during the war. Although he did support the state's rights theory, he did not want to fight for a side that included slavery. He could not fight against his part of the country and left home until the war was over. His arrival in this area was a blessing for all. He acquired large acreages of land on the coast and also in the Ten Mile area west of town. When a local man died and there was no public cemetery, Bell donated land on a hill, facing the river to be used for this purpose. It is known today as the River View Cemetery. One of his sons, Frank Bell, was elected one of the first Saint Lucie County commissioners, and was married to Eloise Hendry, daughter of cattleman A. Hendry. Son Jim Bell was the first keeper of the House of Refuge. A forerunner of the U.S. Coast Guard, the House of Refuge was built at the natural inlet on North Hutchinson Island. This building housed the keeper and provided refuge to shipwrecked sailors and settlers. The wives and children of the Fort Pierce area were sent there whenever Indian uprisings were feared. Sailors also sought refuge in this building when the hurricanes hit the shore.

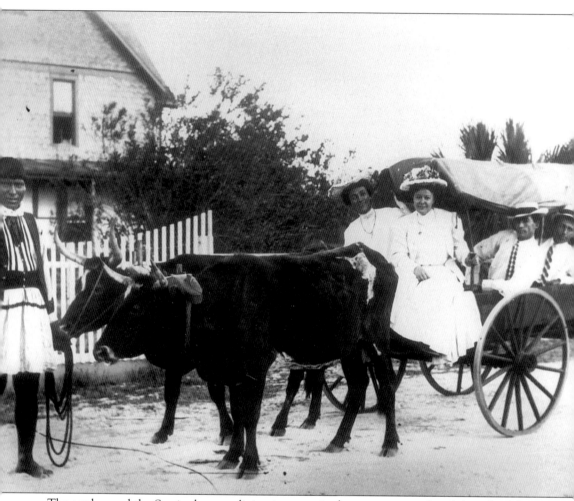

The settlers and the Seminoles were living in peace in the same area, and each benefited from the service of the others. With no taxis in town, these two gentlemen hired a Seminole to lead his oxen to take the ladies, Kathy Godfrey and Nina Butt, for a ride. The gentleman back of the ladies is Clyde Killer, and his companion is not identified.

In 1894, Henry Flagler decided to extend his railway south, resulting in numerous changes in the area. His engineers always drove the same engine, and each took interest in seeing that his was the finest looking engine on the tracks. One of the engineers, Joseph Knowles, decided to move his wife and family to Fort Pierce. Engineer Knowles was later chosen by Flagler to take the first train into Key West, and Flagler accompanied him in the engine. Joseph and Mae Viola Knowles remained in Fort Pierce, rearing a fine family who also remained as contributing citizens.

Engine 116 was always driven by Joseph Knowles. He remained the envy of other engineers because of Boss Flagler's preference to have Knowles as the engineer for all special trips.

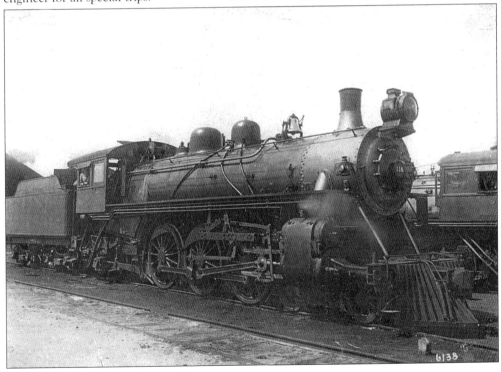

The year 1894 proved to be an important time to this area. The extended business of the Florida East Coast Railway opened up the area for business and population. It was also the year of the great freeze up the coast in the Cocoa, including the Titusville area, where most of the commercial citrus groves were planted. The freeze not only ruined the fruit, it also killed the trees. Sen. Hiram Smith Williams, the first senator for Brevard County, was one of the growers. He learned that the small acres of trees were untouched by the freeze in the Fort Pierce area. He and his son came with associate W.R. Moses to test the soil. Williams purchased property in the Ten Mile area west of Fort Pierce, formerly part of the pioneer Bell homestead. He started the commercial citrus business that is now one of the largest industries in Fort Pierce. Senator Williams is pictured with daughter Myra, wife Cornelia, and son, Sydney.

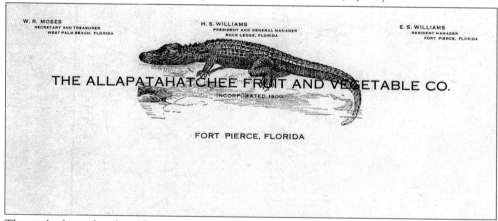

This is the letter-head and logo for the first commercial citrus grove: The Allapatahachee Fruit and Vegetable Co. Young Sydney's Alma Mater, the East Florida Seminary, later became the University of Florida and also adopted the alligator for its mascot. Allapatahachee is the Seminole word for alligator.

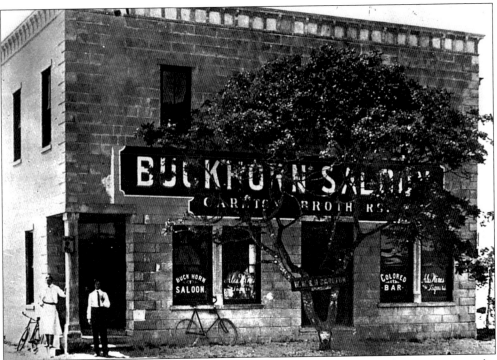

Goss Tucker's Tarpon Saloon soon had a competitor. With the population growing, the Carlton boys decided that it would be good business to open another saloon, and it would also give them some entertainment after working cattle all day. Called the Buckhorn Saloon, it was located on Second Street. The exterior of the Buckhorn Saloon, with a tree in front for cool shade, seems to be attracting customers.

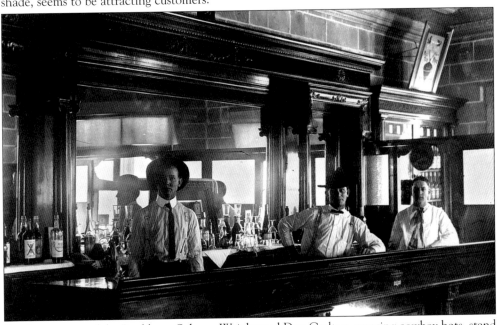

Brother-owners of the Buckhorn Saloon, Wright and Dan Carlton, wearing cowboy hats, stand with their helper to welcome their customers.

The ladies of the community were anxious for churches to be built. They would sail up and down the river to each other's home and plan fund-raisers, such as picnics. At these picnics men would bid on baskets of food and also dine with the cook. Soon there were more churches than saloons: Baptist, Methodist, Episcopal, and Presbyterian.

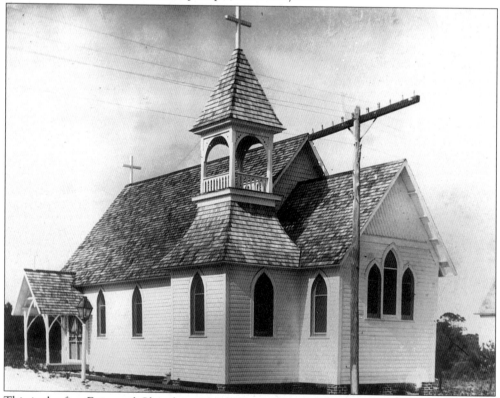

This is the first Episcopal Church on North Second Street. The parents of the late Governor Dan McCarty were charter members. This church building was later sent up the coast to Cocoa, Florida, on a barge. The congregation built the larger St. Andrews Episcopal Church and School on the location of the first church.

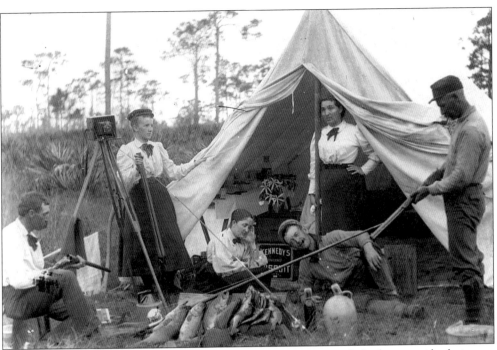

In the days before family radios, televisions, and computers, people had to provide their own entertainment. These unidentified citizens had been fishing, hunting, drinking from the little jug, taking pictures, and perhaps even courting. The ladies may have been invited for the refreshments prepared on the table in the make-shift tent.

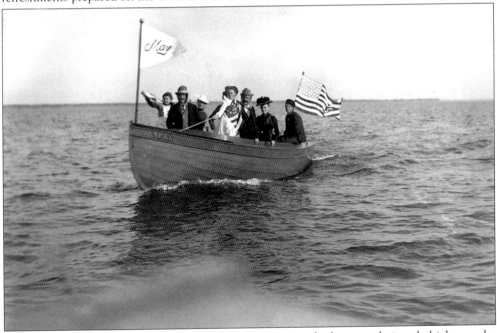

Since there were no paved roads, most of the pioneers used a boat on their only highway, the Indian River. These boats also provided entertainment. It was exhilarating to sail on the beautiful calm water, enjoying the cool breeze, the lovely country, and congenial friends.

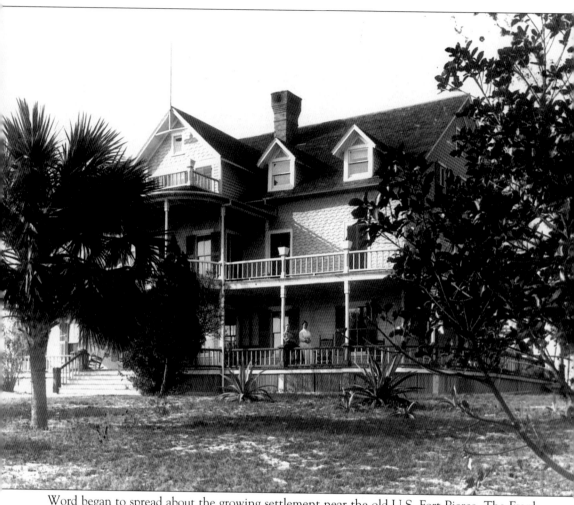

Word began to spread about the growing settlement near the old U.S. Fort Pierce. The Frank Tylers recognized the need for a hotel. This building filled the need in 1901, with the gracious Tylers as hosts.

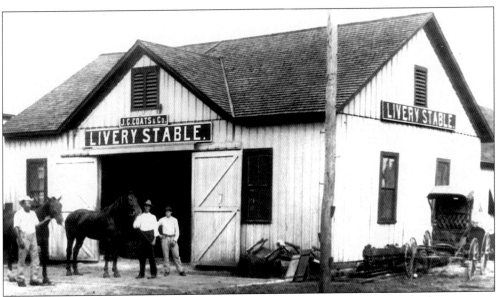

Young Green Coats came to this area in 1897 to help set out the first commercial citrus grove for the Allapatahachee Fruit Company from Rockledge, Florida. After this task, he purchased the town livery stable, consisting of a few horses and wagons. He built up the stable until it contained one hundred Tennessee working mules, 35 riding and buggy horses, with a number of nice wagons and buggies. All were available for lease for pleasure, transportation, and hunting and camping trips. Green Coats stands in the center with a horse in front of the Livery Stable with two of his employees.

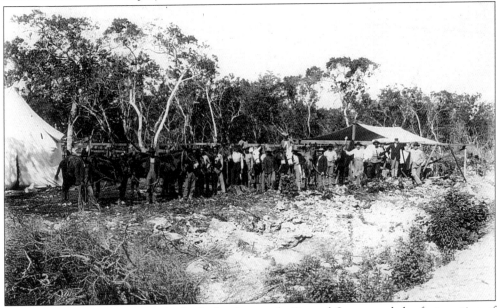

With the mules and scrapers, he built the first roads, Second Street, and the first portion of Avenue A and Orange Avenue, from crushed oyster shells shipped down by rail from a mile long oyster mound, built from the discarded oyster shells of the first inhabitants, the Ais Indians, of the area now named Wabasso, Florida. With mules and scrapers, he dug ditches, and dug the first artificial inlet to the ocean here for the fishermen.

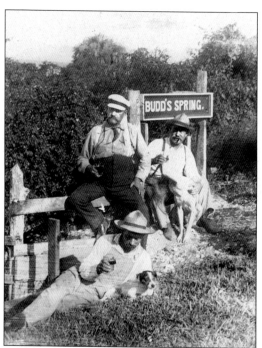

One of the newcomers from the North, Colonel Budd, decided to entertain and earn a little money by serving drinks from the only fresh water spring in the area, the spring at the old federal Fort Pierce. Not only did pipes have to be drilled down into the earth for any other fresh water, the product also had an unpleasant flavor caused by the tannic acid in the ground. This water was known to stain white clothing when used for laundry. Water pipes on certain parts of the river ridge produced white water that was later sold in bottles for drinking water. Colonel Budd is enjoying the company of two hunting buddies and their dogs.

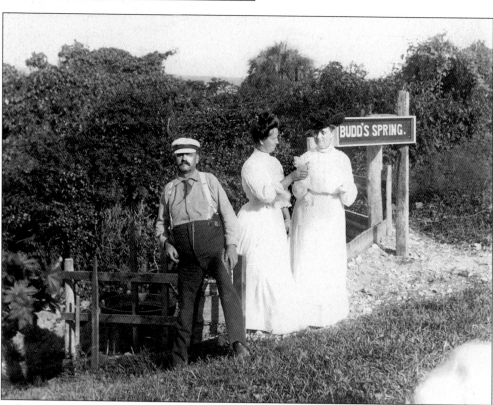

Ladies also enjoyed visiting Budd's spring for the cool fresh water. These two ladies celebrate a toast, as they click together their glasses of spring water.

26

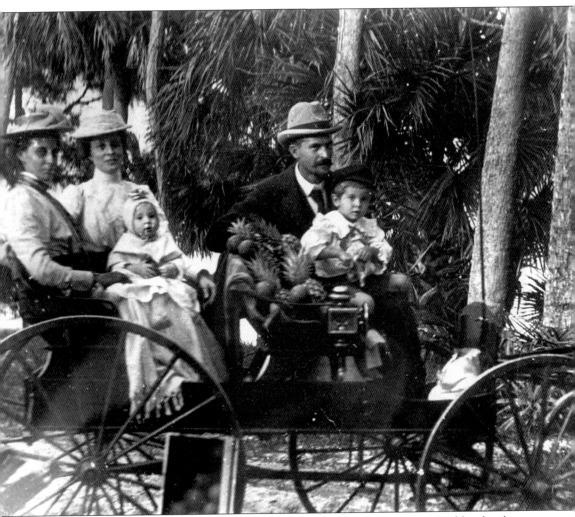

Eventually, the pioneers had a doctor move to their area. Dr. C.P. Platts moved his family to Florida in 1895, due to a rare blood disease that required a milder climate. He moved to Melbourne, where his uncle was the head of the bank. He soon learned that there was no doctor from the coast of Melbourne to West Palm Beach, and none out west to Kissimmee. He decided to move to Fort Pierce. There was great rejoicing at his arrival. He was never known to refuse a call. He used a bicycle for his town calls, a sailboat named *The Alligator* for his calls up and down the coast, and a horse and buggy for his calls out west to Okeechobee and Kissimmee. Indians brought their ill to him and camped out in his yard until the patient could go home. They paid him with the wild game he could use for food. Dr. Platts is taking his family to church in the family buggy. His son, George, is helping his father and learning to drive a buggy. His wife, Mrs. Platts, is holding the baby daughter, Helen, and is seated with her twin sister, Mrs. Vina Hogg. It was the year 1901.

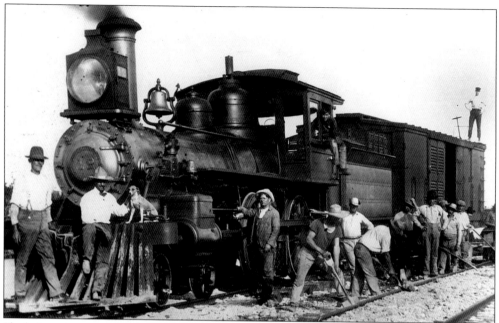

Flagler's train was opening up the territory of south Florida. It created jobs for the young men to build the tracks and work on the trains. Not only the people, but even the pets seem to be pleased in this picture. It appears that "Happy is the dog that has the opportunity to become a train hobo."

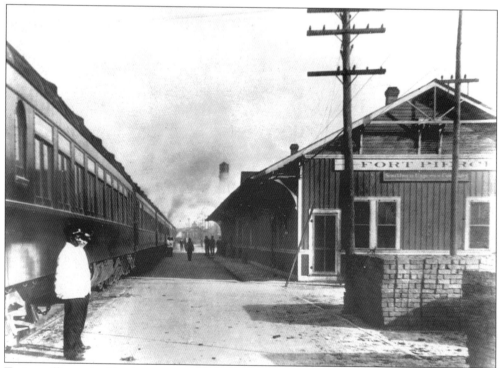

Train traffic resulted in the community taking pride in having a fine train station, and the two porters standing beside the waiting train take pride in their uniforms.

The sand road, called Indian River Drive, ran south down the peninsula. Horses and mules pulled the wagons and buggies with little difficulty; however, as more settlers arrived with automobiles, they easily became stuck in the sand.

Indian River Drive was one of the areas that the Green Coats Livery Stable was hired to cover with crushed oyster shells in order to provide better driving for those pioneers who lived along this waterway.

Pioneer ladies shared the same hardships as their husbands, and like them, they seemed to take joy and pride at their accomplishments. The lovely Mrs. Bell, of one of the first families to arrive, proudly shows a pineapple that grew on their land, as well as a beloved daughter who closely resembles her mother.

Horace Greeley Stouder came to Fort Pierce in 1903; one year later, his wife, Lettie, and daughter, Marion, joined him. Stouder was in poor health, and had been told to seek a warmer climate. After building a home, this former cowboy from Wyoming became a pineapple farmer. Daughter Marion married James Lynn Hoeflich in 1915. The current descendants of this pioneer family are Marion's two daughters, Edith Hoeflich Luke and Marion Hoefllich Greenwood and their families.

Benjamin and Annie Hogg now had three children, and Annie decided to sell her one-room store. Peter Cobb (seen at right) had been helping her, and he remained to work for the buyer, a canning company which had sent down a crew to can the river oysters. After a year, the crew declared they had exhausted the supply of oysters. The company sold the building to Peter Cobb. There were still plenty of oysters, but the men could not stand the swarms of mosquitoes that caused many to call the town "Port Fierce" instead of Fort Pierce. Others referred to the area as Can Town. Peter Cobb became the new owner of the store Annie Hogg started. He became one of the most admired and trusted businessmen.

Peter Cobb added to both the store and the inventory. Persons sailed from small settlements up and down the river to trade with his store. It became a place to visit with friends, as well as a place to shop.

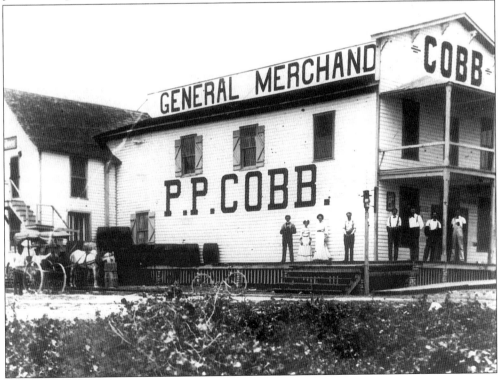

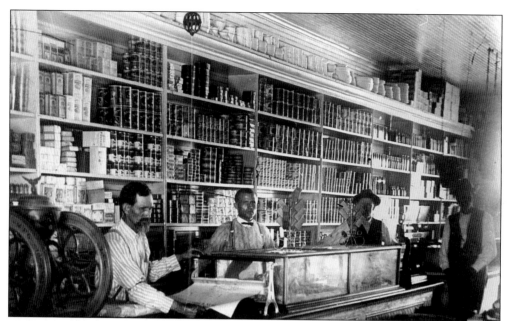

With the railway to bring supplies, Cobb's Store carried goods that the pioneers previously had been able to purchase in the cities near their past homes. There were barrels of flour, sugar, and coffee. The location served as a department store, bank, and post office. Since there was no real bank, Cobb allowed the cattlemen and farmers to keep their money in his safe until they could sail up to a bank at Titusville. The United States Post Office was also there.

Peter Cobb hired Charles Croghan to drive a horse-drawn carriage to take and to deliver orders of groceries and goods to the pioneer ladies. He had come with his parents in 1899 when he was five years old and he knew all of the settlers and where they lived.

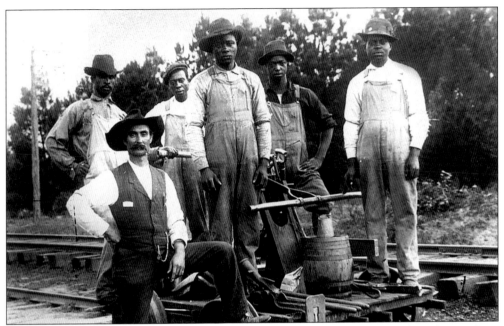

Citizens were fascinated by the railroad hand cart that ran on the rails. Kid Matheson, front left, and his crew would take turns pumping the large bar to make the cart roll. They were called the "Gandy Dancers" and used the cart to go to places along the track to fix repairs, or attend to train wrecks.

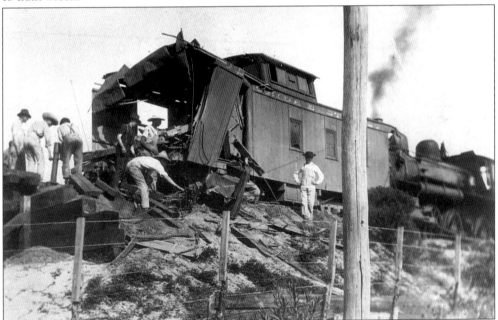

Kid Matheson became a hero. When he reached a wreck, he found a man was trapped beneath one of the cars. Due to the fact that the soft sand could cause the railway car to roll down and kill the trapped man, Matheson immediately started to crawl under the car to remove the injured man. Others warned Matheson of the danger, but he went on to save the man, not considering the consequences.

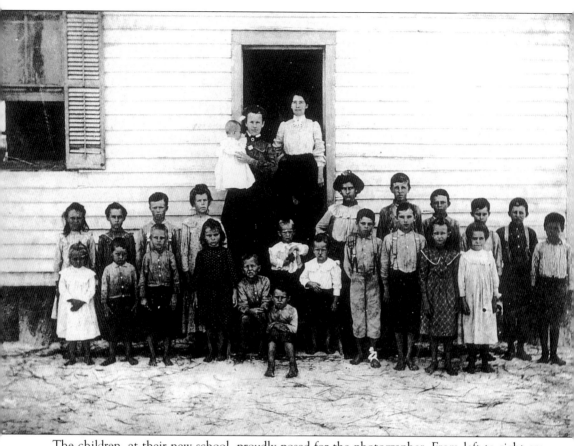

The children, at their new school, proudly posed for the photographer. From left to right are the following: (front row) Annie Barton, Freeman Knight, Billie Anderson, Olive Swain, Tom Swain, Marvin Knight, Louis Drawdy, Lee Drawdy, Minor Holmes, Nathan Holmes, Ada Barton, and Lettie Anderson; (back row) Gertrude Barton, May Swain, Jim Anderson, Mary Anderson, Callie Drawdy holding baby Ray, teacher Miss Emma Bell, Sophia Hair, Redden Knight, Douglas Barton, Geniral Hair, Elbert Knight, and Jimmie Miller.

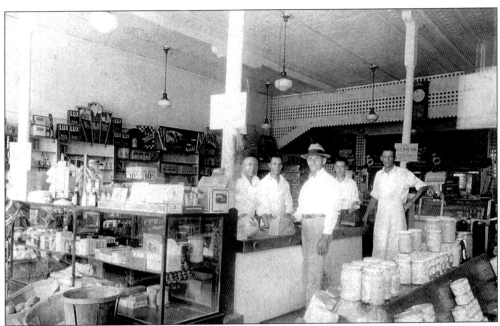

The community was called by several names: Edgar Town, Can Town, and finally Fort Pierce became the legal name when concerned citizens met, incorporated the town of Fort Pierce, and elected the town officers. Holtsberg became a new merchant in town. In the interior of his store are his clerks Randy Osteen, Randolph Hurst, and Vance Howard, with a customer, the gentleman in the hat.

"Friends, Romans, Countrymen,
Lend me your ears
While I extol the wonderful virtues
Of these splendid wearing Regal Shoes"
is probably what Mark Antony would have said, had he ever enjoyed the pleasure of wearing a pair of Regals. That pleasure denied him is accorded you.

ALL STYLES. ALL SIZES. ALL COLORS.

HOLTSBERG'S

HOLTSBERG'S
GROCERY AND MEAT MARKET
Phone 296 Phone 297

Fort Pierce, Fla., 1-7-193

The pioneer merchants knew how to advertise and attract customers. The prices listed on the ticket of one of their good customers, a prominent contributing family, is almost unbelievable except to one of an older era. Can you remember when a loaf of bread cost 10¢?

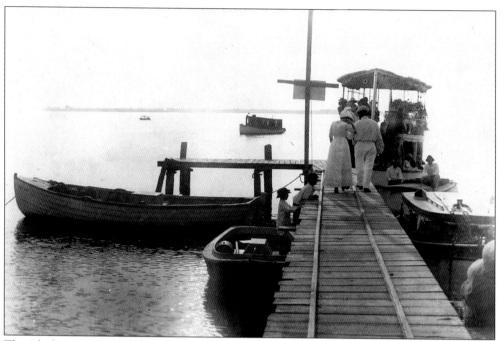

Though the pioneers mostly sought property for homes along the river, they also enjoyed going over to South Hutchinson Island to take pleasure in the beach and the waves of the Atlantic Ocean. They made up parties of friends, clubs, or churches to take the *Susie C.* ferry to the surfside beach.

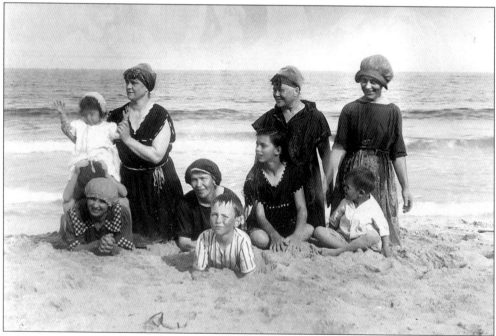

All generations seem to enjoy the surf and the sand on the beach. Most ladies of the era wore long hair and were careful to have it contained under hats or scarves. The women are above are clad in bathing suits, not dresses, a testimony of their modesty and morals of that era.

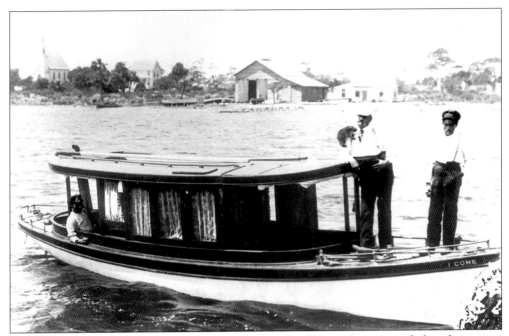

The river (that is not a river) gave the pioneers much pleasure: boating with friends, or even a pet raccoon and their crew. It was their means of transportation and communication. Until the railway started to carry the mail, it was often brought by the trade boats, or the mailman in his boat.

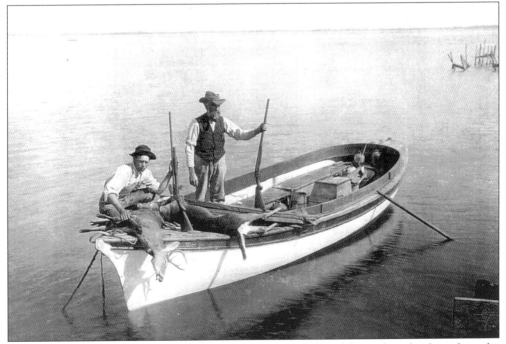

These men used their boat to go hunting. Deer were plentiful on the islands and in the back country west of town. Children often had this meat between homemade biscuits in their lunch pails.

Two ardent fishermen throw their lines in eager anticipation as they fish in a stream near the Savannas.

This street, Depot Drive, ran by Flagler's East Coast Railway Passenger Station. Across the street is Goss Tucker's Tarpon Saloon where the railway workers and the local fishermen and farmers liked to gather in the evening. It had competition when the Carlton brothers established their Buck Horn Saloon east on Second Street.

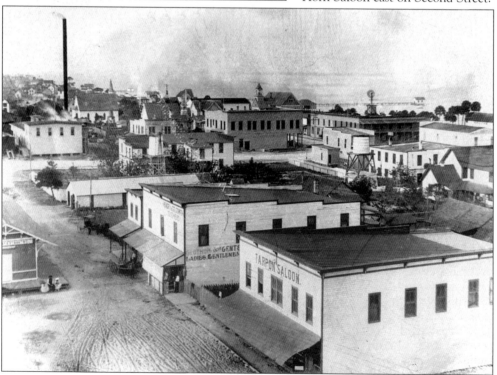

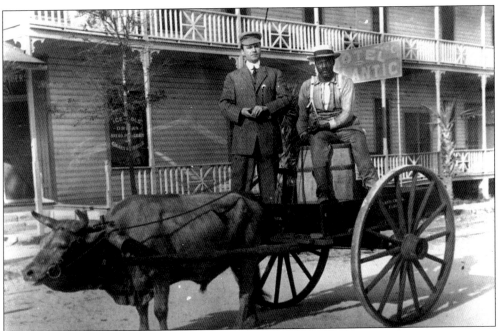

This young visitor to pioneer Florida requested that this picture be taken while he used the ox cart. He wanted to amuse his friends up north by showing them this southern "taxi" being used in Fort Pierce.

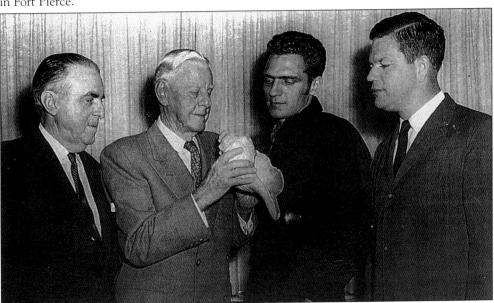

Mr. A.B. Michael, a trade boat captain in his youth, shows these men—Harold Collee (left), an unidentified youth, and Doyle Rogers, brother of Congressman Paul Rogers (right)—how he used a conch shell as a horn to attract the attention of his customers living along the river. They would row out to the boat and shop for groceries, yard goods, clothing, corsets, kerosene, perfume, seeds, and garden tools. They also received news from the crew about the other families living up the coast. The railway soon put these trade boats out of business and made it possible for more stores to open in the communities.

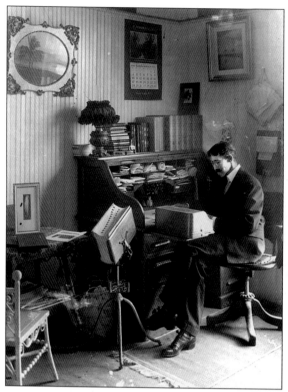

Harry Hill established the first photographic business. He is working at his desk, where he recorded his subjects, and created a photographic history of this section of Florida, now known as the Treasure Coast. Mr. Hill, with his artistry, his cameras, and his scholarship was a treasure to his community.

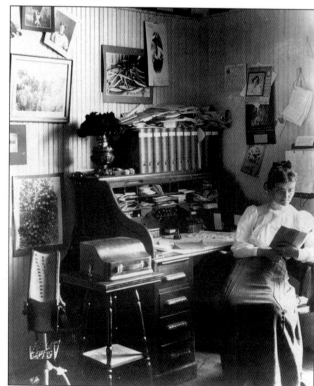

Mrs. Hill, even though a mother, was Harry Hill's greatest helper in the business, and certified the often repeated quotation, "Back of every successful man is a woman."

Many low places would become shallow ponds in the rainy season. The pioneers enjoyed digging these ponds deeper, stocking them with fish as a control for mosquitoes as the fish ate the larvae, fish to catch and eat, and for raising aqua-fowls that would nest on the islands built from the dredged earth. The myrtle bushes and the banana trees gave shade for the ducks and their nests, as well as provided delicious fruit.

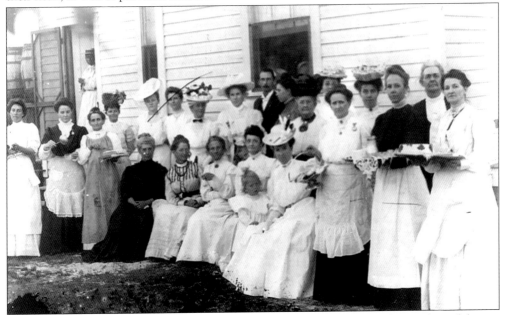

When the first church, the Baptist church, was built, the ladies delighted in cooking delicious food and desserts to sell as a fund-raiser to help buy hymnals, a piano, and to make a donation to the minister's salary. Here they wait for their families, friends, and the single fishermen, cowboys, and railway workers to come to buy this good home-cooked food.

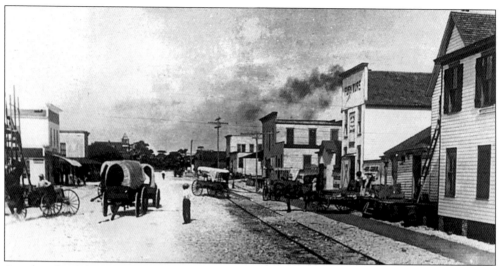

A storm cloud threatens as one looks west on Avenue A. It has had its sand ruts covered with ground oyster shells. There are new buildings on this route, evidence of the continuing growth in the population of the area.

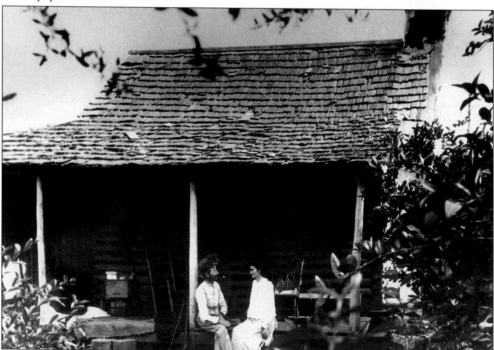

This unidentified couple is housed in a rustic cabin, typical of those built by the first settlers. The porches were well used to get the breezes, except in mosquito season when all used a mosquito brush, hanging at the door, to brush off mosquitoes. People also rushed indoors where iron smudge pots, with rags sprinkled with B-Brand Insect Powder, were burning and smoking to discourage mosquitoes from coming into the house. Everyone slept under a large mosquito net that was tucked under and around the mattress. The pallet on the porch, placed there for the tired husband to stretch out on and rest in the cool breeze of the porch, indicates it is not mosquito season.

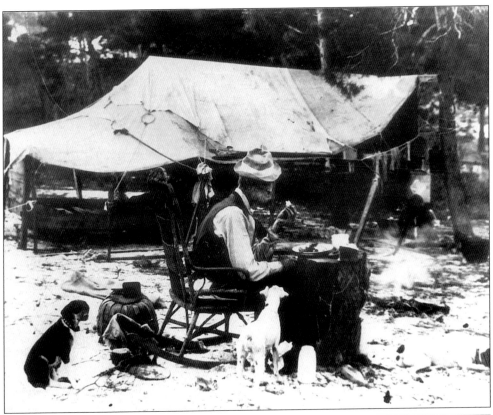

This elderly gentleman, Colonel Pitts, though living in town, uses his tent for a home for both him and his dogs. They appear to be waiting patiently for their dinner. His tent is on the corner of North 4th Street and Avenue F.

Almost all of the pioneers had a boat of some kind, for the river was their only highway, and only means of travel for long distances prior to the coming of the railway. Many of the single men lived on their boats. The Indian River Lagoon was protected from the large ocean waves by the barrier islands, and these men are enjoying sailing, or perhaps they are planning to sail over to Cobb's Dock and join others at the Tarpon or Buck Horn Saloon before they retire for the night on their boat.

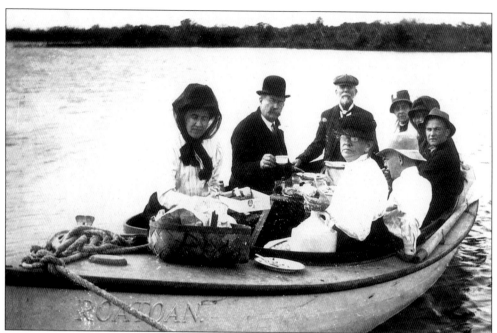

Often, older couples would go in a boat to join others on South Hutchinson Island for a picnic. Each would prepare a basket of food for a family. They would always have fresh meat from the deer, bear, or wild turkeys and quail that inhabited the woods.

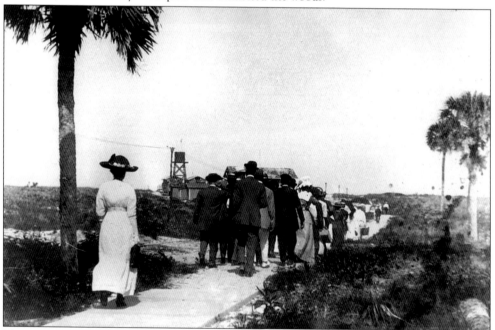

The picnickers would tie their boats up on the west side of the island; they would then carry their baskets and blankets to sit upon on the east side of the island. There, they would sit and visit or walk up and down the beach to collect shells to string to hang in front of the windows to block the sun light. They inhaled the cool, clean salt air. They always dressed as if going to church, for each wanted to look his best when in public.

Miss Katie Turner, a pioneer school teacher, was hired to teach in Okeechobee, which then was in Saint Lucie County. She was met at the train by the chairman of the school's Board of Trustees, William Lee Coats. He later courted her and married her. She was a wonderful mother to their five children, and was a strong supporter of his political and civic activities. Mr. Coats was elected to two terms in the Florida Legislature, and was appointed by Gov. Cary Hardee to represent Florida at an Agriculture Congress in Washington, D.C. He took a correspondence course in pharmacy at the Ohio Institute of Pharmacy, at the urging of Dr. Platts and was the first pharmacist at the Platts and Cobb pharmacy. When the children were all in school, Miss Katie taught again for the next 30 years.

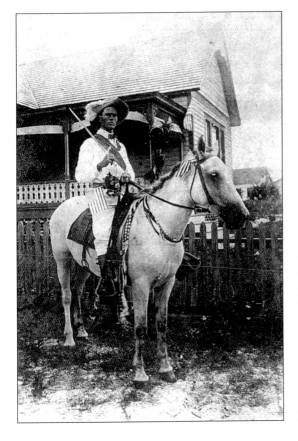

In 1905, The Florida State Legislature created Saint Lucie County with Fort Pierce the County Seat. Its borders were the Sebastian River on the north, Saint Lucie River on the south, Kissimmee River on the west, and the Indian River on the east. A great celebration was planned for July 4th, with a parade led by William Lee Coats on a white horse. He wore red, white, and blue ribbons across his chest, a plume in his hat, a flag and red, white, and blue flowers on his saddle.

45

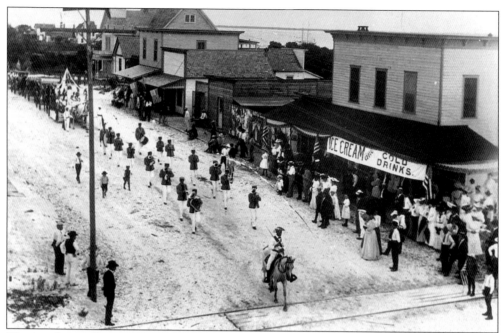

The parade, celebrating the creation of Saint Lucie County, passes by Cobb's Store where, on the way down to the park by the river, one can buy ice cream and cold drinks. The town band marches, playing stirring music for the horse-drawn float with girls on it, and the public officials walking in the parade.

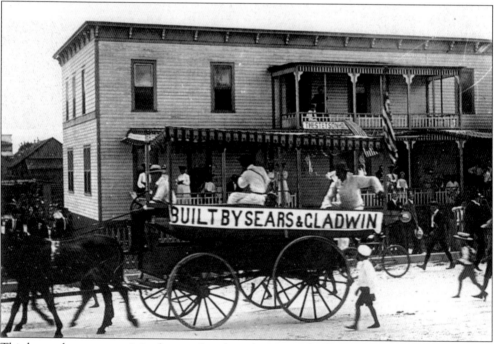

This horse-drawn wagon is in the parade, where far more vehicles were powered by horses than by engines. Members of the Gladwin family were leading pioneers in the area, always participating in elective offices and organizations that helped to improve the community.

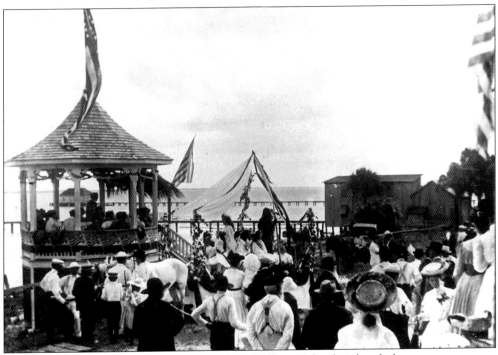

Citizens gather at the park by the river to hear William Tylander's band play a concert.

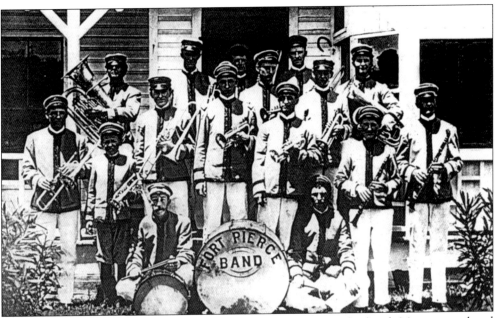

William Tylander, soon after his arrival in Fort Pierce, organized a band. Many men played musical instruments, and the band was used for special celebrations up and down the river. Band members (left to right) are as follows: (front row) Al Snodgrass, Hughie Montgomery, Elwyn Thomas, Banty Saunders, A.B. Lowery, and W.E. Tylander; (middle row) Dr. Feigel, Casper Mims, Homer Conklin, and Clifton Holliday; (back row) Ellie Mims, Green Coats, Wilson Godfrey, Gene Hoefnagle, and Frank Stetson.

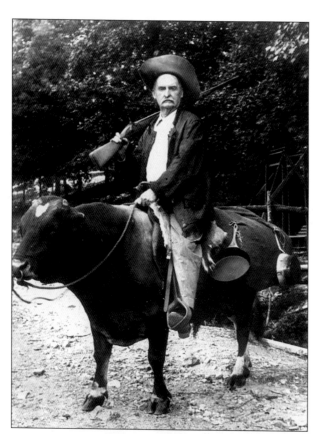

Will Tucker, on his ox, demonstrates the usefulness of the animal for traveling and camping out on a hunt. The ox helps him participate in the parade.

Will Tucker and the new county share a special date. Here, his friends are celebrating his birthday after the parade celebrated the creation of the county. No matter how warm it was in July in 1905, men and women were clad in their Sunday-best clothing.

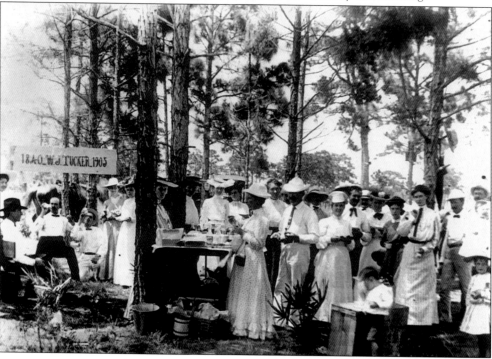

In September 1905, gentlemen of the Bar are meeting for the first term of the circuit court in Saint Lucie County. Seated is Judge Minor Jones, descendant of the Paine family. Standing to the extreme right is Otis R. Parker Sr.; second from right, newly appointed Sheriff Robert Leonard; third from right Charles T. McCarty; fourth from right, Fort Pierce Judge James Andrews; and fifth from right, State Attorney Jones of Orlando. The last three gentlemen are unidentified.

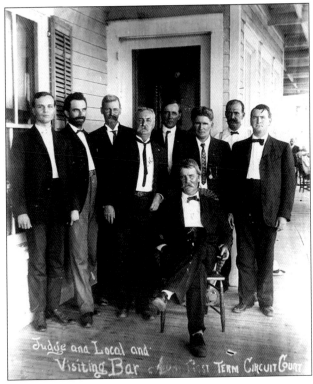

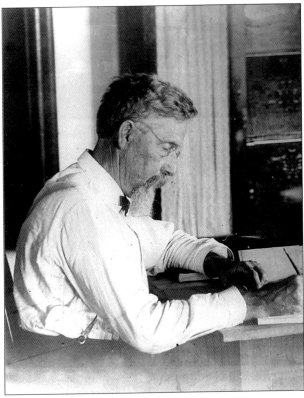

Circuit Clerk J. E. Fultz, in 1905, is diligently attends to his responsibilities.

The pioneers did not have weather equipment to predict the need to prepare for a hurricane. They had the Seminoles, however, who recognized the movement of certain birds and insects that continually fled the area when a storm was threatening. They also knew how to read the sky. This photograph shows a storm gathering in the sky. The pioneers called the strong threatening winds "gales."

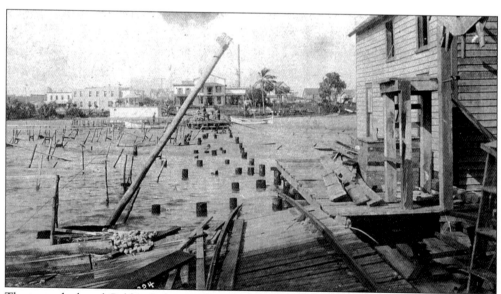

The town dock and Cobb's dock were destroyed by one of those fierce gales. Each dock had fish houses at the end that were destroyed also. The pioneer homes were built to withstand the gales. The strong timbers had braces that were bolted to the timbers.

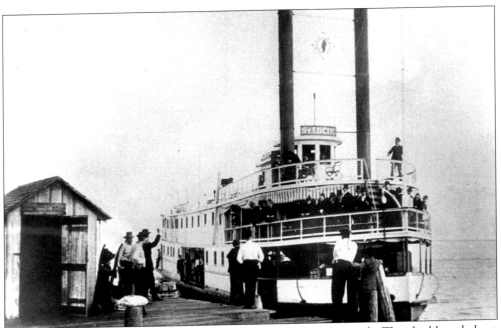

Large steam boats began coming down with sportsmen from the north. They had heard about the great fishing and hunting opportunities in the area. Often, they brought their families, for the area had several nice hotels and rooming houses. The *Saint Lucie* is docked here, bringing many visitors to enjoy a veritable Eden.

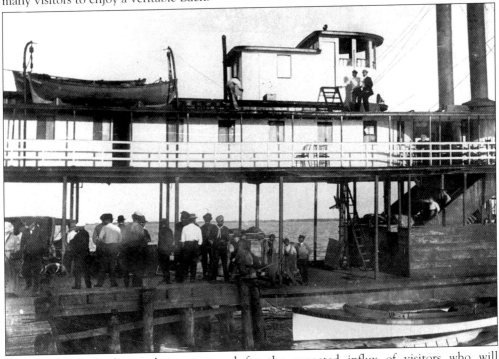

This double-deck ship is being prepared for the expected influx of visitors who will come for vacations, and for those who are planning to homestead property and become permanent citizens.

United States Senator M.S. Quay, in the center, with his son, Dick Quay, on the left, brought some of their Washington friends to visit the area. Senator Quay annually visited with his Senate colleagues for hunting and fishing.

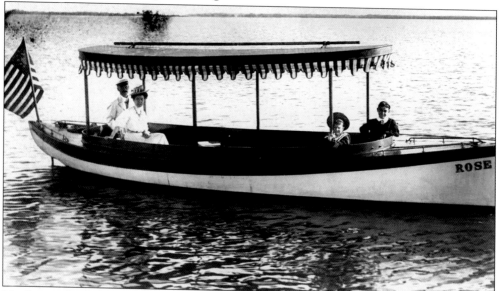

Mr. Rupert N. Koblegard rides in his launch *Rose* with his family. His wife, for whom the launch was named, sits with him, and their sons, Rupert Jr. and Ruhl, are in the bow of the boat. This family came from Washington due to Rupert Junior's chronic life-threatening illness. His doctor believed that a warm climate was the only chance to recover. Koblegard was so impressed with the area and the possibility of developing it that he purchased property and was successful in his many businesses and in saving his son. His descendants still live here, and granddaughter Mary Ann Bryan was elected a city commissioner for many terms until her retirement.

Three
THE FISHING INDUSTRY

The Indian River Estuary is a part of the Atlantic Ocean, but separated by approximately 155 miles that contain only two small natural inlets, one at Fort Pierce and the other at the southern end at Jupiter. This lack of openings to the ocean limited the numbers of the predatory fish that would enter, and the delighted pioneers found the estuary teeming with fish, oysters, and clams. Soon, many residents were engaged in the fishing industry, shipping hundreds of barrels of fish a day by boat, packed in barrels of ice. The railway added to the success of the fishing industry. It also aided the tourist industry, for it was a convenient way to travel. As word spread about the wonderful fishing, more and more sportsmen of means came and invested in property.

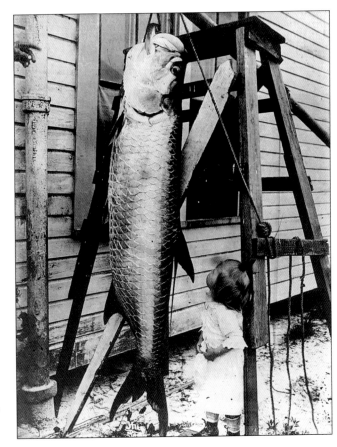

Harry Hill, the pioneer photographer, saw his little daughter, Kathryn, fascinated by this huge tarpon, and captured the scene with his camera.

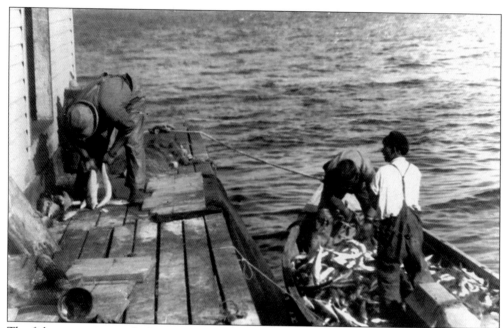

The fishermen came with their boats loaded with fish, and more fish houses were established.

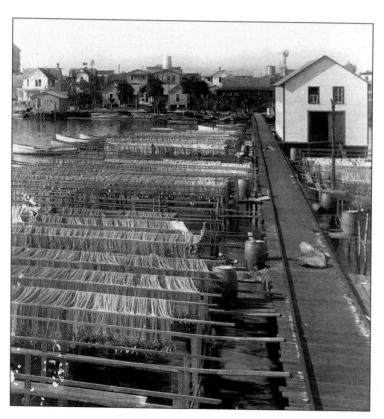

Fish houses began springing up and in great demand. Adrian Sample, who came from North Carolina with his brothers, had a fish house at the end of a dock. He had rows of rods for the fishermen to hang their nets to dry. He took an interest in community affairs and was elected superintendent of the county schools.

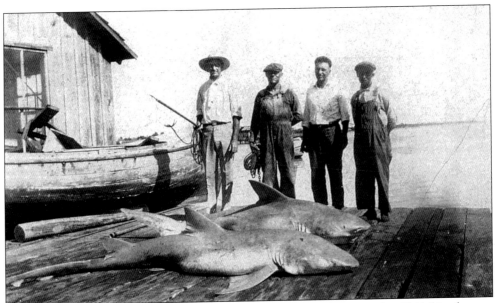

Bill Reed, on the left, pioneer merchant Fred Holtsberg, and two unidentified friends were photographed in order to prove the size of the sharks caught on their fishing trip.

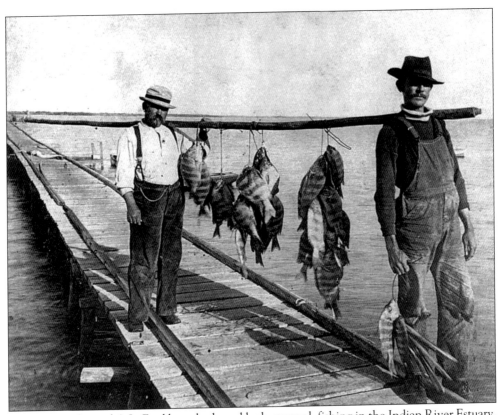

E.C. Summerlin and A.L. Ford have had good luck, as usual, fishing in the Indian River Estuary.

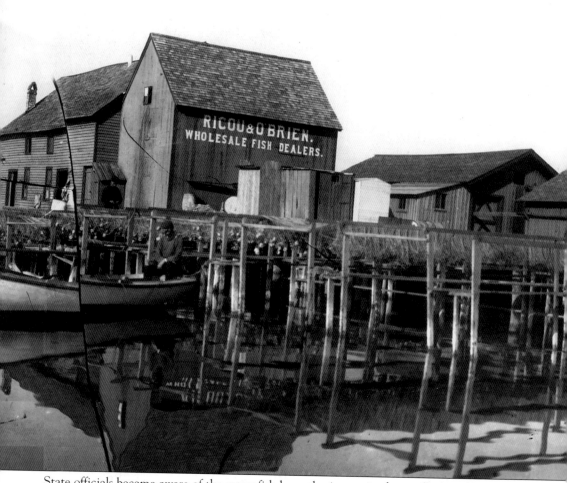

State officials became aware of the many fish house businesses in the small area of Fort Pierce. The reports of the many barrels of fish being shipped out each day caused laws to be enacted to prevent the Indian River from being over-fished. Some young fishermen who sold their fish to the Ricou Fish House were caught fishing mullet out of season. Their boats, nets, and fish were confiscated and the men were tried in the court of Judge Miner Jones. Defense Attorney Pat Whitaker had the arresting conservation officer give the correct scientific definition and description of a fish. He then cut open a fresh mullet, removed an inner organ which he asked the officer to identify. The organ was a gizzard, not included in the officer's definition of a fish. The fishermen were found "Not guilty" for the court ruled they did not have fish in their nets. The court came to the conclusion that they had mullet that had a gizzard; therefore, because of the gizzard, the mullet must be, not a fish, but an aqua-fowl—a "sea chicken."

W.B. Cross stands near the large fish that two fishermen have brought to his wholesale fish house.

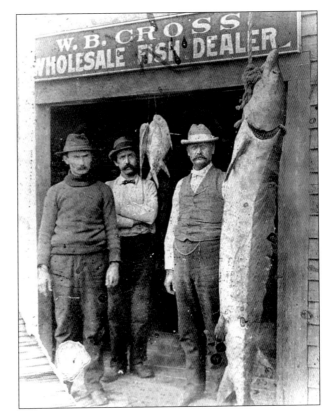

The Summerlin family enjoyed fishing, and the brothers were popular guides for fishing and hunting for the many sportsmen who had discovered this area.

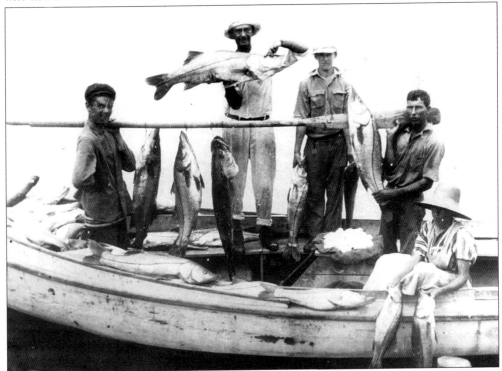

From left to right are Brittany, little brother Sage, and mother Christine Molle. They are one of many families who represent a fifth generation of descendants of pioneer families who have chosen to remain in Fort Pierce.

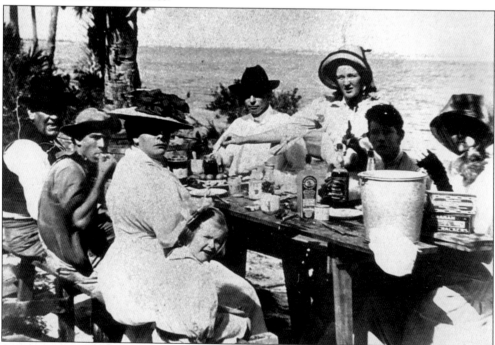

A favorite social gathering was the fish fry with cooked swamp-cabbage (heart of the sabal palm), home cooked bread, lemonade, and pineapple pie. This family had out-of-town visitors and treated them to a riverside fish fry.

Four
THE CATTLE INDUSTRY

Rueben Carlton and his wife Elizabeth brought their family to this area seeking grazing land for their herds of cattle. There were no fencing laws at that time, so cattlemen moved when the herd needed new grassland. Carlton had a home on the river, but he also acquired land in the Ten Mile area for the cattle, and had a camp there. Later he and his children all had nice homes in that area. Soon other cattle families moved to Fort Pierce, including Hendry, Alderman, and Holmes. In later years, younger men became ranchers along with the descendants of the first cattlemen.

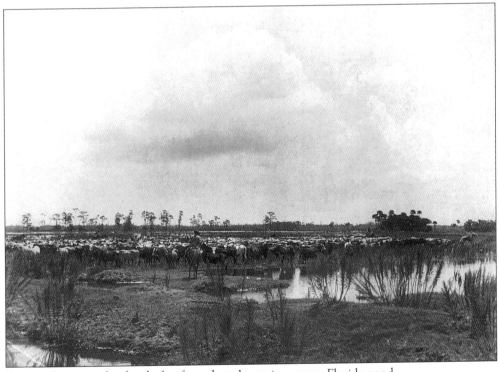

One cowboy attends a herd of unfenced cattle grazing near a Florida pond.

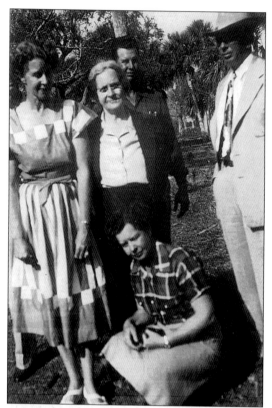

Rueben Carlton's children remained in the area as cattlemen and citrus growers. This is son Charles's family: (from left to right) daughter Alberta; Mother, with daughter Maggie at her knees; and sons Rueben and Thad. The youngest son, Karl "Big Boy" Carlton, is absent.

This is Cattleman Nathan Holmes's family: (from left to right) Margaret (who married cattleman Charles Carlton's son, Reuben II), Lavern, wife Mary, Nathan, and Vieva H. Hardy.

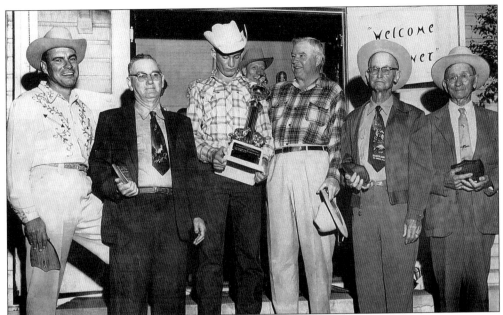

Cattlemen of several generations are pleased to award a trophy to an outstanding student in the Future Farmers of America organization. The cattlemen are, left to right, as follows: Bill Padrick, Nathan Holmes, Judge Alto Adams, Wright Carlton, and B.E. Alderman. These cattlemen, and absent dairyman Alfred Cleveland, were given plaques and honored for being in the cattle business for 50 years or more.

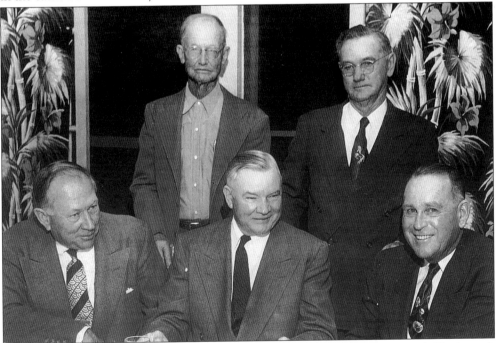

These cattlemen are having a luncheon board meeting, planning the annual Cattleman's Parade. Seated at the table from left to right are O.L. Peacock, Judge Alto Adams, and an unidentified member; standing from left to right are Wright Carlton and Nathan Holmes.

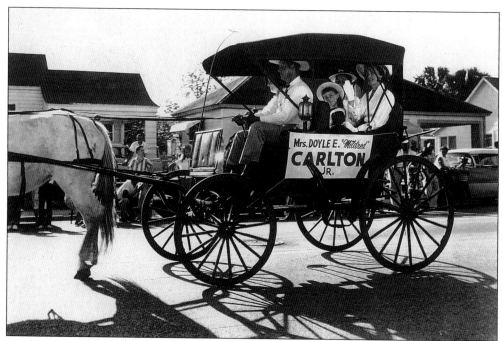

Cattleman Rueben Carlton II drives the horse-drawn buggy in the Cattleman's Parade. His passengers are his cousin, Doyle Carlton Jr., son of the former governor Doyle Carlton; Mrs. Doyle Carlton (Mildred) and daughter; and Mrs. Rueben Carlton (Margaret).

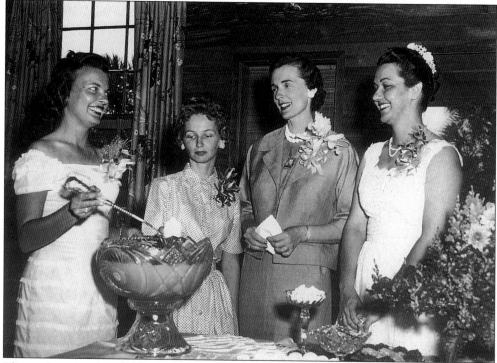

The cattlewomen honor Mrs. Doyle Carlton at a tea. Mrs. Alto Adams Jr. (Dorothy) is serving an unidentified young girl, Mrs. Doyle Carlton, and Mrs. Rueben (Margaret) Carlton.

Cattleman Burgess Elliot Alderman Sr. and wife Dollie Lee brought their cattle from Bassenger, Florida, and had a large ranch out west from the Fort Pierce shopping district. He was one of those honored during the Sandy Shoes Festival for ranching over 50 years in Saint Lucie County. Mr. Alderman had three sections of land for his ranches, one extending into Okeechobee County.

This family gathered for the 60th wedding anniversary of B.E. and Dollie Alderman. Included are their children, the children's spouses, and their grandchildren. From left to right are (front row) W.E. Sr., Dollie, and Cindy Sauls; (middle row) Jean Alderman, Frances Alderman, Joyce DeLong, Thekla Sauls, Kyle Vanlandingham, Larue Vanlandingham, and Ernestine Vanlandingham; (back row) Eliott Alderman, Ray DeLong, Bert Sauls, Saundra Sauls, Leslie Sauls, and Pierre Vanlandingham.

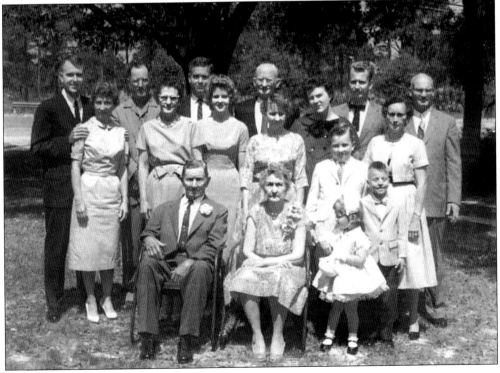

In 1937, Alto Adams Sr. established a ranch that his son, Alto Jr. managed after he graduated from the University of Florida. The ranch that he and his sister Elaine Harrison inherited was expanded to three operational ranches in Okeechobee, Saint Lucie, and Osceola Counties, totaling 50,000 acres, under Alto "Bud" Adams' management. This family photo, with (from left to right) Lee, Dot, Mike, Robert, and Bud, was taken on the Fort Pierce ranch where they have their home.

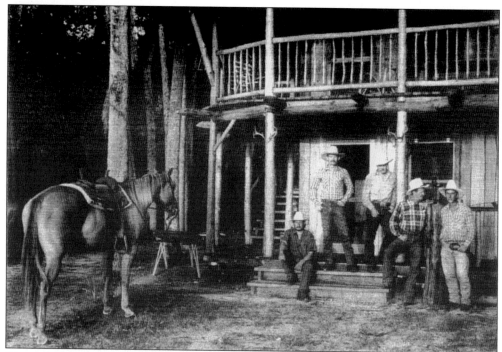

The Adams Ranch cattle crew (once called cowboys)—Steve Nutler, Billy Adams, Buddy Adams, Ralph Pfister, and an unidentified man and horse—wait for their orders for the day at the ranch office.

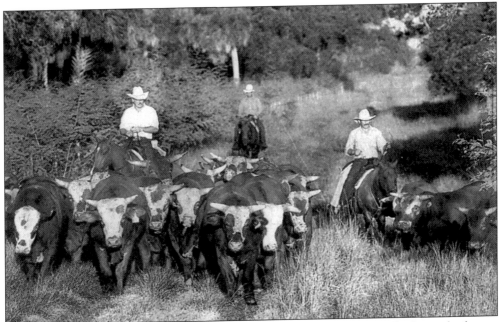

All ranches have been fenced since the fence law of the 1950s. With the end of open ranges, it is easier for the cattlemen to round up the cows, as these Adams Ranch cattle crewmen are doing.

Bud Adams, a respected and honored environmentalist, nature photographer, and lecturer on native birds, animals, and ranching was the recipient of the 2003 Entrepreneur Award of the four-county Indian River Community College district. He has created an internationally successful new breed of cattle, the Braford. It was bred to have high quality meat and to be able to tolerate warm weather conditions. There are 25 members of Judge Alto and Cara Adams's children and grandchildren who have homes on the ranch where these cattle were originally bred.

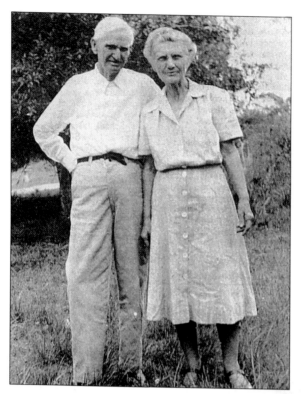

Dairy Cattleman Alfred Cleveland came to Fort Pierce in 1908, married Myrtle Killer, purchased the dairy of Abe Hilliard, increased his acreage and cattle, and built their home on the land. This was before the days of bottled milk and milking machines. He drove large cans of milk in his horse-drawn wagon, and dipped out the milk into the containers his customers furnished. After the invention of milk bottles in 1917, he quickly became accustomed to them. In 1925, his dairy offered chocolate milk, made from Mrs. Cleveland's own chocolate syrup recipe.

Turner Coats, another dairy cattleman and farmer, joined with his son, "Chip" (Turner Jr.), breeding, raising, and training thoroughbred racing horses and racing quarter horses at their Flying T Ranch. Chip, soon to be called for the Vietnam War, left the University of Florida in his senior year, and shows by the pleased expression on his face, the joy of working with these fine horses.

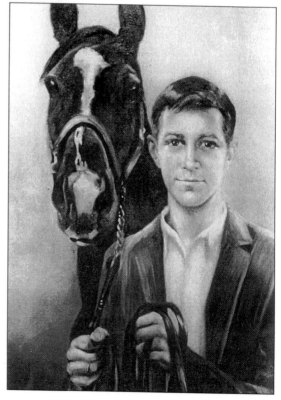

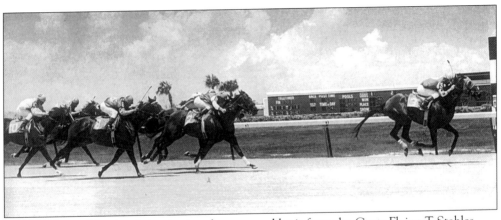

The lead horse, Number 3, is winning the race, and he is from the Coats Flying T Stables.

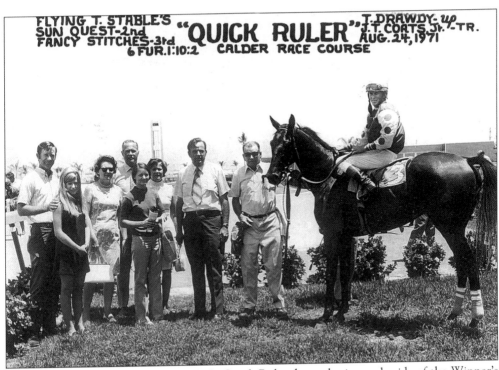

The owners of the winning horse, No.3- Quick Ruler, have the joy and pride of the Winner's Circle. The persons in the picture, from left to right, are as follows: Chip, behind unidentified teen; his parents, Arleen and Turner Coats behind another unidentified teen; co-owners of the horse, Lyda and husband Judge Eddie DeFriest; a Calder employee; and Jockey Terry Drawdy.

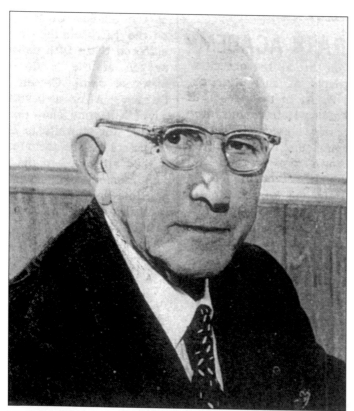

William E. Tylander was the leader of the town band. He was here was to work for the East Coast Lumber and Supply Company, established in 1903. The pioneers were eager to have the lumber to construct homes and businesses, no longer satisfied with palm log cabins with palm-frond thatched roofs.

The East Coast Lumber and Supply Company was equipped with modern conveyances, no longer using horse-drawn wagons. Clayton Almond is the proud driver of this fine truck purchased by the company. This company celebrated 100 years of service in 2003.

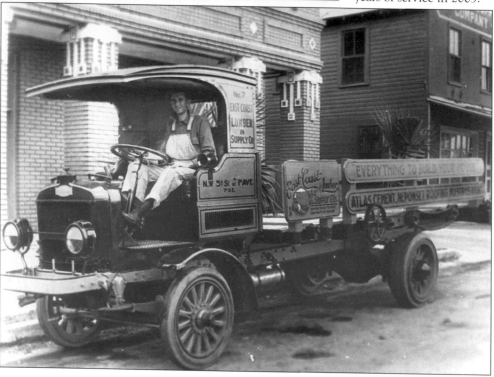

Five
AGRICULTURE

The land was so rich that the farmers did not have to use much fertilizer. Some of those who came to homestead land in 1842, at the time that congress passed the Armed Occupation Act, brought pineapple slips to plant. Early homesteaders left after four years because of reoccurring trouble with Native-Americans, who had previously resided in southern parts of the state during the Seminole Wars. The pineapple plants remained, producing large and sweet fruit and showing later pioneers the fertility of the soil for fruit. Many pioneers began to grow pineapple, sending them by boat, and receiving a very good price for the crop. The river ridge became the setting for many pineapple plantations.

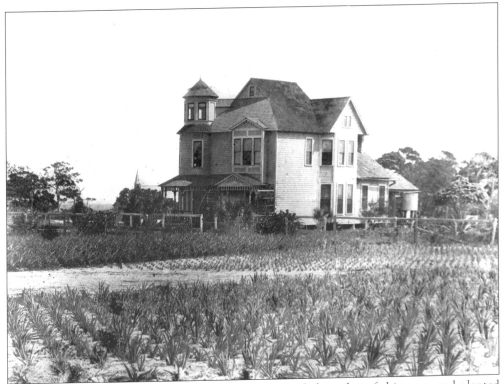

The first mayor of Fort Pierce, Mayor Dittmar, realized the value of this crop, and planted pineapples in the land surrounding his home.

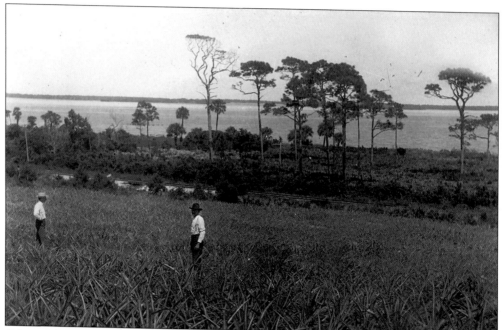

Others followed Dittmar. One example was Charles T. McCarty, who came to this area with his wife, Barbara Elizabeth, in 1888. He was an attorney, but the small population did not require his services full-time, and he had a natural love for agriculture. He became a horticulturist of note by studying the soil and climatic conditions of the east coast of Florida, and became one of the largest pineapple growers in the state. McCarty proudly shows one of his pineapple fields to a newcomer.

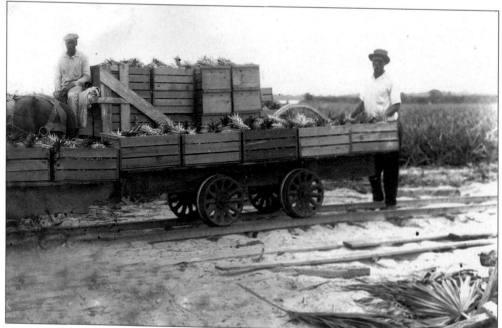

Boards were put on the sand so the horse carts carrying the pineapples out of the field would not get stuck.

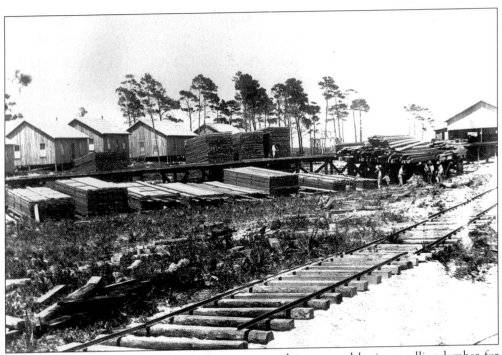

The East Coast Lumber and Supply Company was doing a good business selling lumber for pineapple storage sheds as more and more citizens started growing pineapples.

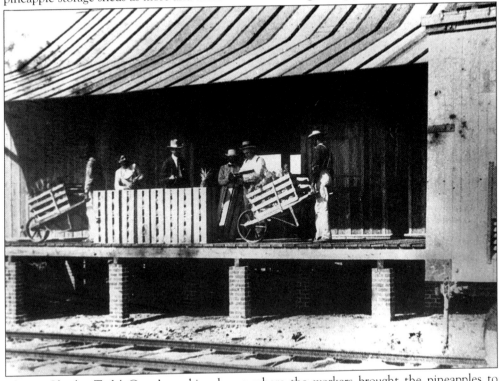

This is Charles T. McCarty's packing house where the workers brought the pineapples to be crated.

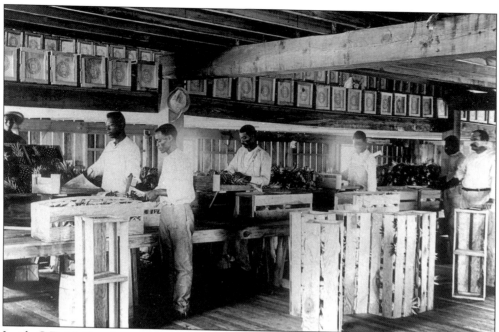

Inside C.T. McCarty's packing shed, the workers place all of the pineapples in crates that will be stored there until the ship arrives to carry them northward. Some of these workers are descendants of runaway slaves who had fled to Florida and lived with the Seminoles. Others are descendants of freedmen, or came by boat from the Bahamas. They had no trouble getting jobs.

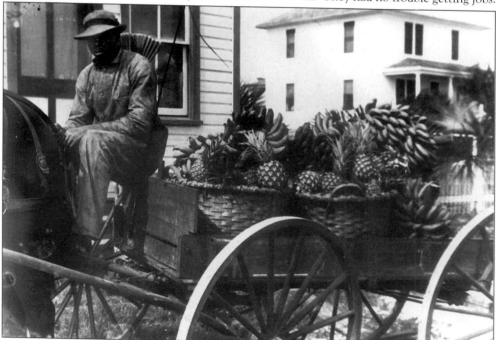

This pineapple grower sold his fruit to housewives and to the hotels and restaurants. These customers, who were not growers, appreciated this service. The pineapple had become the King of Crops.

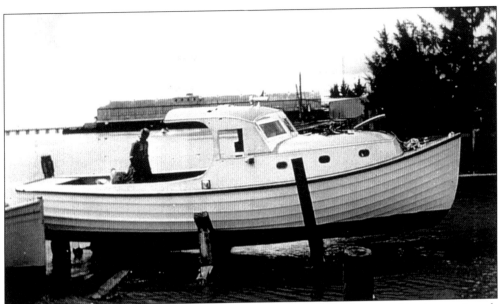

Boat building became a necessary business with the growth in population and businesses. Joseph Roberts came to Florida at the age of three in 1888. As an adult, he became a commercial fisherman, and fished for the Ricou Fish Company, earning 5¢ a pound. He started building boats to help support his family, and soon had many customers. Joe was photographed in the boat attending to the final inspection before delivery. He is facing south on the west bank of the Indian River.

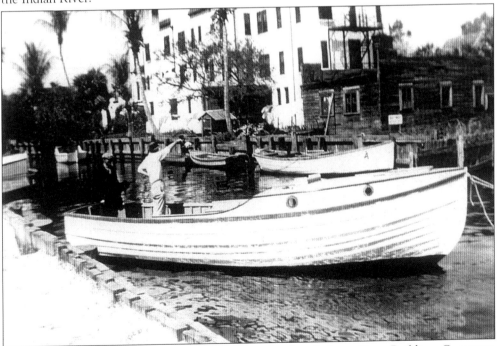

Ruhl Koblegard Sr. purchased this boat from the Joe Roberts Boat Building Company. Roberts built 15 boats for the company that had been buying his fish, the Walter Peterson Fish Company.

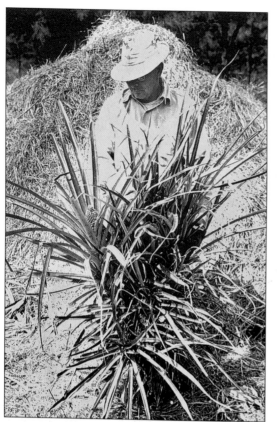

Roberts stored his boats in Moore's Creek during stormy weather. His boat company joined the Backus Boat Company building boats for the United States Government during World War II. Both Joe Roberts Sr. and Jr. established a Cooperative Fish House in the area. Boats by Roberts also were used to transport the pineapples up and down the coast.

The coming of Flagler's railway had seemed a blessing to the growers of all fruits and vegetables. Pineapple growers were getting very rich. Suddenly, the railway ruined the pineapple business. Cuban growers began to bring their fruit over to Florida to ship north on the trains. They could out-sell the Florida pioneers, for their labor costs were far less, and this competition ruined the pineapple business of the area. One of the few growers of the pineapple in the 1930s was P.K. Platts, son of the first doctor in Fort Pierce. Platts, an educator, grew pineapples for 40 years. The crop was replaced by citrus as a major industry in the area.

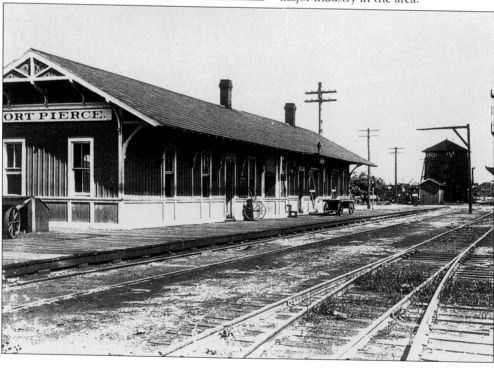

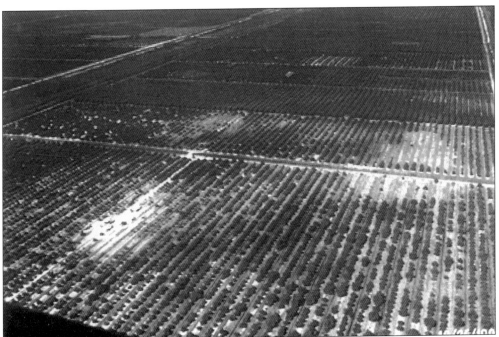

The Allapatahatchee Fruit and Vegetable Company was thriving and planting more acres of citrus. Many pineapple growers changed to the growing of citrus. There were many varieties, and the soil and climate were good for the crops of oranges, grapefruit, lemons, and limes. This aerial view shows the length and arrangement of the rows of trees.

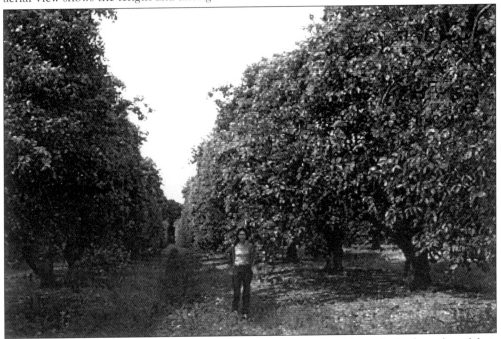

A winter visitor had her picture taken in a Florida orange grove where she had purchased fruit to ship home. It shows the size of the citrus trees and how far apart the trees are set for growth and harvesting convenience.

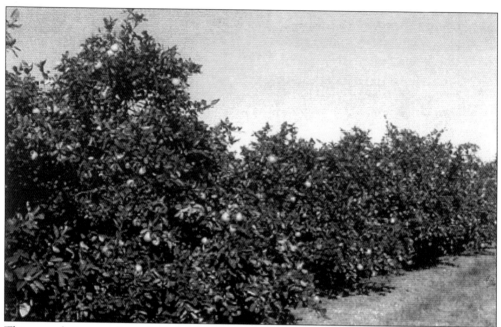

This grapefruit grove has a large crop of fruit. Grapefruit is shipped from Fort Pierce to many states and countries. China is a customer of large orders. The Europeans first obtained citrus from China, and the Spaniards brought citrus to their newly discovered peninsula, La Florida, which now is selling citrus to that original source, China.

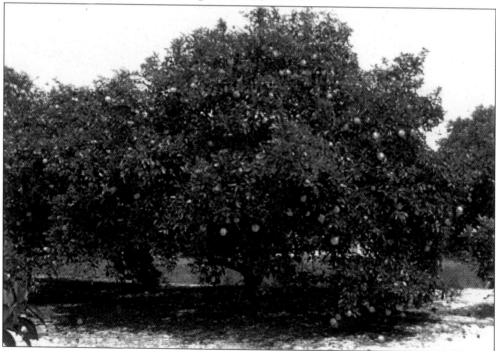

This orange grove in Fort Pierce shows the golden fruit that has inspired poets to write of these groves as Florida's gold mines. There are varieties that ripen in different months, so fresh orange juice is available most of the summer.

Six

GROWTH OF THE AREA

EDUCATIONAL AND CULTURAL INSTITUTIONS

The affluent sportsmen, who came for hunting and fishing pleasures, realized the development potential of this beautiful area with the fertile soil, the mild climate, and the many beautiful waterways: the Indian River, Saint Lucie River, Moore's Creek, and Ten Mile Creek. A group of United States Senators, friends of Senator Quay, formed a hunting and fishing club and visited annually. Others who learned of the charm of the river area from friends, relatives, and the trade boat captains also came to the area. The local officials began improving roads, other merchants came, and soon Fort Pierce even had a newspaper.

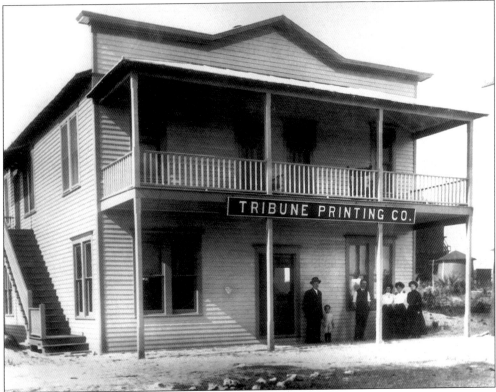

In 1903, Charles Emerson and Arthur Brown started a newspaper, using a room at the old Buckhorn Saloon. In 1905, Archie Wilson and P.J. Reed acquired the paper and named it *The Saint Lucie County Tribune*, and had this building for the publishing of the paper. In 1920, Glen Chapman was the owner and named it *The News Tribune*. The Enns family became the owners in 1929, and recently it has become the property of the Scripts-Howard Publishing Company.

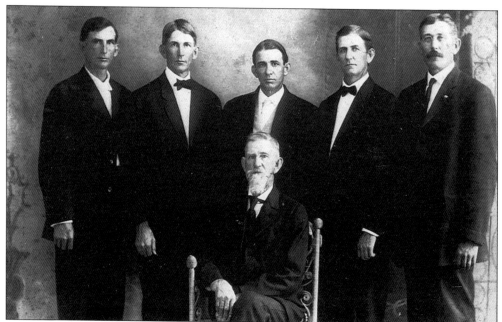

In 1893, the Sample family was still living on the ancestral farm, near Charlotte, North Carolina, established during the Revolutionary War. The young sons were unable to establish the family's former prosperity in the post–Civil War economy, where the cotton crop would bring only 2¢ a pound. Upon hearing of new beginnings in Florida, they relocated and prospered. They contributed to schools; Adrian had an ice house and a fish house, and was elected School Superintendent. They helped to establish the First Presbyterian Church. Harry opened a theatre, and John was a partner in a wholesale grocery business and grew pineapples. Here they are with their proud father, David Sample. Standing behind him from left to right are Harry, John, Frank, Adrian, and Neal.

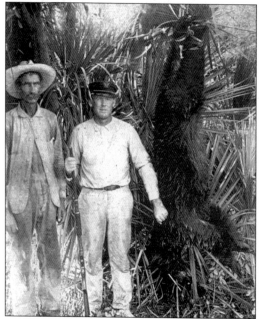

Though the population was growing, no one built homes or businesses on the islands. There was no bridge across from the mainland, and boats were the only transportation to reach the island shores. With a large population of bears, the islands attracted hunters, such as Capt. Byron Dawley and friend Holliman (in the straw hat), for a bear steak.

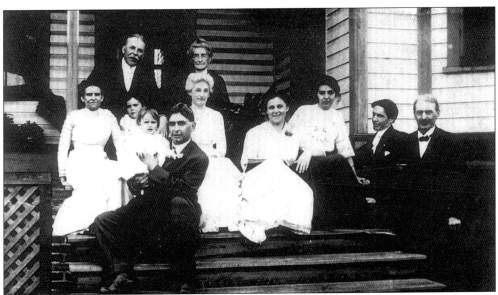

The Fee family first resided in Melbourne where William Miller Fee, M.D. was believed to be Melbourne's first doctor. In 1902, Frank H. Fee, founding director and president of the Melbourne State Bank established in 1893, relocated the Melbourne State Bank to Fort Pierce, changing the name to Bank of Fort Pierce. This pioneer family gathered for a reunion, are, left to right, as follows: (front) holding Baby Mary, is Fred Fee; (second row) Emma Fee (wife of Fred), their son William Morgan Fee; unidentified lady; Bess Fee (wife of W.I. Fee); unidentified lady, unidentified brother of Frank Fee (George or John), and W.I. Fee; (top row) Frank H. Fee (father of Fred and W.I. Fee), Margaret I. Fee (wife of Frank H. Fee.)

Fred Fee, an attorney at law, established his practice in Fort Pierce in 1905. He served as a County Judge and a member of the Legislature. He was a founding director of The First Federal Savings & Loan Association of Fort Pierce.

Frank H. Fee II was born in Fort Pierce in 1913. He joined his father's law firm, practicing as an attorney from 1935 through 1983. He served as mayor of Fort Pierce, Saint Lucie County Attorney, and as member of the State Legislature. His son, Frank Fee III, is an attorney in the firm of Fee, Koblegard, and DeRoss. It is the oldest law firm in Fort Pierce and Saint Lucie County, remaining in continuous service since 1905.

W.I. Fee established a Hardware Store and Mortuary. Since hardware stores sold the caskets, the mortuary was typically in this location. The bodies of Florida's Ashley Gang were brought to this location after they were caught and killed on the Sebastian Bridge in 1924. W.I. Fee took the lead in ridding the area of the mosquitoes by persuading Floridians from Jacksonville to Miami to use drainage ditches and to stock all ponds and ditches with fish to eat the mosquito larvae. He also led the citrus growers to form the Indian River Citrus League to protect the name of Indian River Citrus only for those grown in the area of the Indian River.

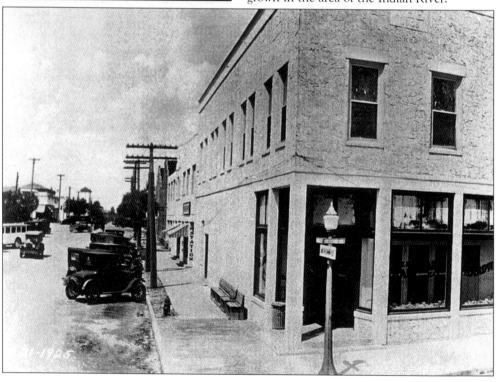

Robert Reed Gladwin came in to the area 1898, three years before the town of Fort Pierce was incorporated. He was in the hardware business and soon joined with George Backus in the boat building business. He became active in civic affairs and served as mayor, was the fourth president of the Board of Trade (forerunner of the Chamber of Commerce), and after the creation of Saint Lucie County, was elected to the County Commission.

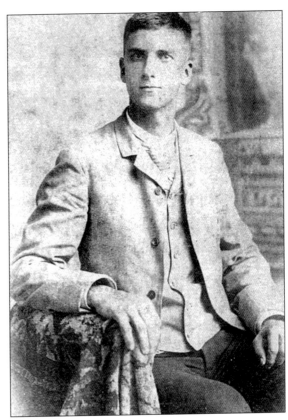

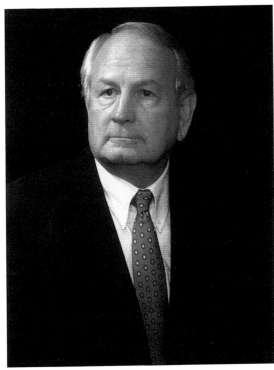

Science has declared that there is a memory gene that can be passed to other generations. The city of Fort Pierce might declare that it can prove there is a civic-service gene. This is a photograph of the present mayor of Fort Pierce, Edward Gladwin Enns, the grandson of a former mayor, R.R. Gladwin. Enns is in the seventh year of this service, and like his grandfather, also was elected to the Saint Lucie County Commission, where he served 12 years. He was elected vice-president of the Chamber of Commerce, and was the first recipient of the President's Award for meritorious service to the Chamber of Commerce.

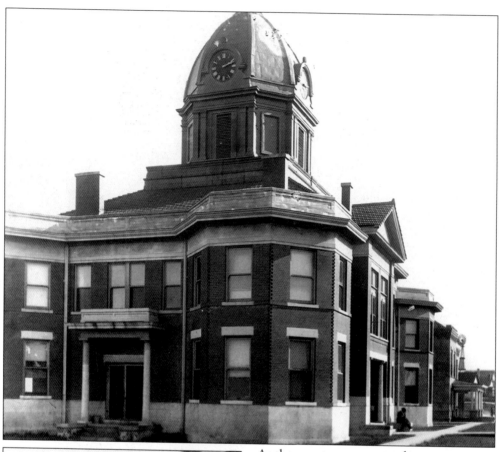

As the county grew, a courthouse was needed and one was built at the south end of Second Street, with all of the necessary rooms for the elected officials, the records, and a court room. Next door was the county jail.

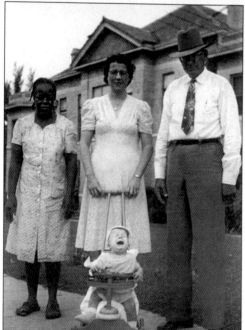

Sheriff B.A. Brown, grandson of Ben and Annie Hogg, stands with his daughter, Lavita, with her first-born son, George. On the left is Smithalee Sheifield, cook for the sheriff's Saint Lucie County Jail.

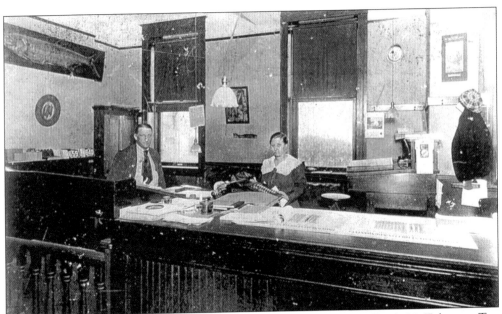

The Tax Collector's Office was in the north end of the court house. Frank M. Tyler was Tax Collector for 34 years, beginning in 1913. His daughter, Margaret Tyler Taylor, assisted him. He and his wife established the first large hotel in Fort Pierce.

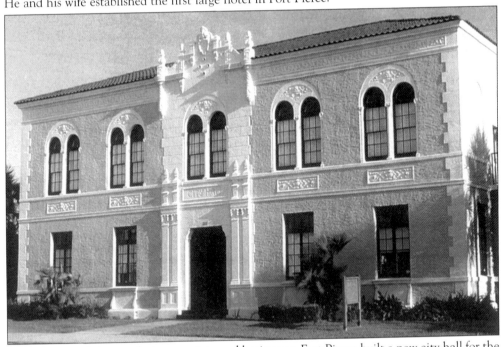

With the growth in population, tourists, and businesses, Fort Pierce built a new city hall for the officials to conduct city business. The Mediterranean style of architecture was appropriate for the South Florida climate. While the building was new, the old charter drawn up for the city in the old East Coast Lumber shed back in 1901 with the first mayor, Dittmar, proved to be as sound and appropriate for the governance of the city as it was in the beginning. The charter was not replaced until 1957.

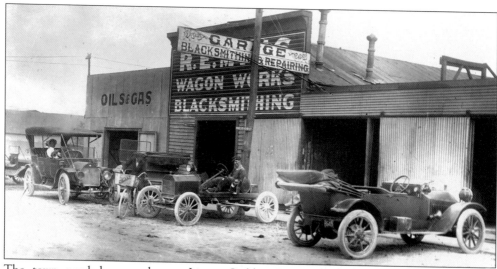

The town needed more than a Livery Stable. Cars were beginning to outnumber the horse-driven wagons and carriages. R.E. Mims opened a garage, in 1915 at 307 Orange Avenue, selling oil and gas, and also serving the others' means of conveyance with blacksmithing, and wagon works.

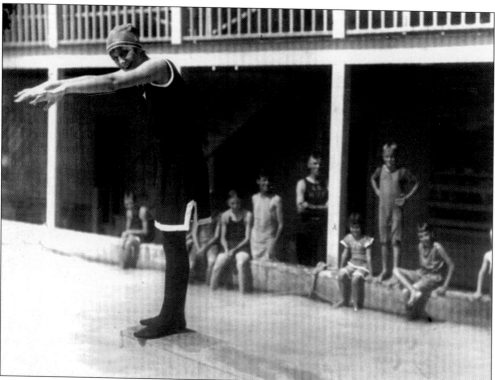

The pioneer Holmes family established a business that brought joy to the youth. They provided the first pool in town, with dressing rooms on the first floor, and a huge room on the second floor for dances, parties, and club meetings. Miss Vi Gustafson, daughter of the city manager, dressed in her fashionable bathing suit of the era, is getting ready to dive into the pool. She is watched—and possibly envied—by a group of children waiting for a swimming lesson.

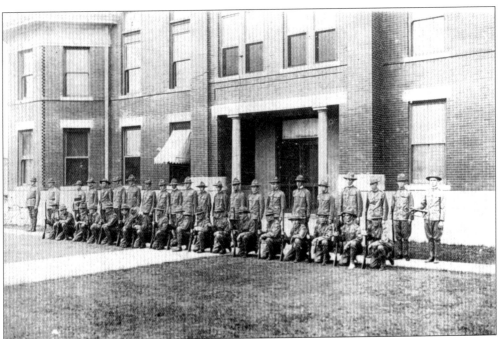

The Home Guard of Saint Lucie County for World War I was organized September 4, 1917. The information was recorded in the County Commission Book 126. The officers were Capt. Bob Lane, Capt. C. Whipple, and Lt. L.F. Collier. Eighty rifles were issued to the guard on December 18, 1917.

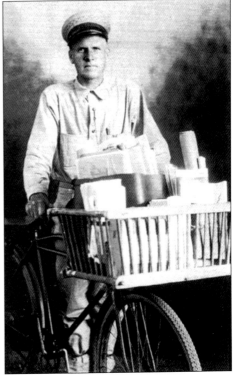

Charles Croghan, whose parents had established a bakery, learned Postmaster Thomas Roden would soon hire the first mailman to deliver mail to the homes in town. He hastened to take the Civil Service exam, applied for the position, and was hired as the first house-to house mailman in 1923. He enjoyed the job, for it gave him a chance to visit with the citizens, all of whom he knew. His dog insisted on going with him, probably the only mailman who liked the idea of having a dog on the route.

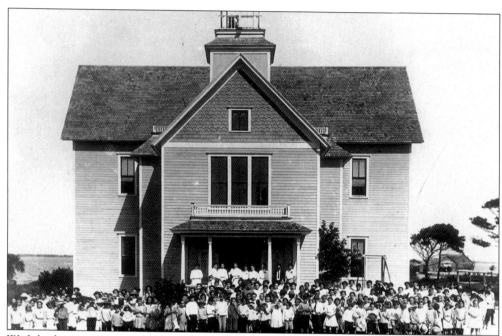

With both an incorporated city and a county, taxes were now available for buildings and streets. How pleased parents, teachers and students were to have this school on North Second Street in 1908.

Mrs. Charles T. McCarty was one of the teachers at the school. While her husband was busy with Law and growing pineapples, she not only taught the pioneer children, she helped to organize a Woman's Club, and was a charter member of the Episcopal church.

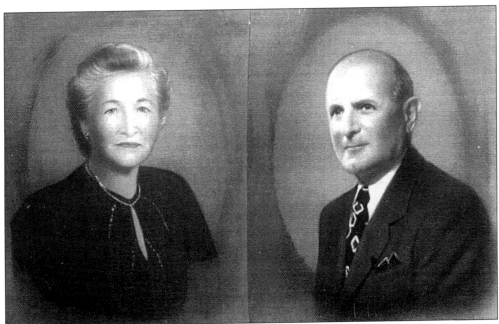

Ralph and Ida Rubin came to Fort Pierce from Cocoa in the 1920s and purchased the Holtsberg Store on North Second Street. The Rubins had four children—Bernard (later a mayor of Fort Pierce), Libbie, Arthur, and Sylvia.

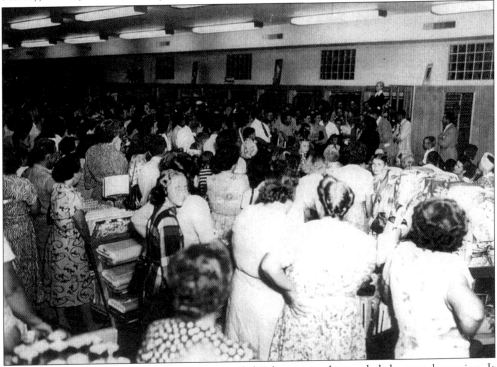

In 1950, the Rubins remodeled the store, and this large crowd attended the grand opening. It was the largest independent department store between Daytona and West Palm Beach. It was in operation until 1987 when son Arthur Rubin retired.

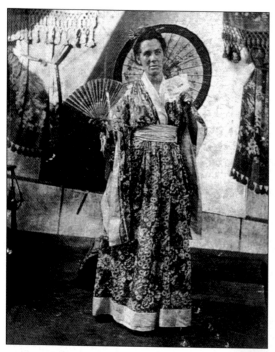

Miss Mary Debogory was a new school teacher. When she arrived, the school in the north section of the community had burned down. The Summerlin family offered a storage building on their property to be used as the one-room school. Their son, Clarence, courted and married Miss Mary who later taught at the large school on North Second Street. She had a beautiful singing voice, and in this photograph she is dressed for her leading role in the opera *Madam Butterfly*.

Fleming C. Dame, his wife Lillian, and children Charles, Olive, and Catherine, moved to Fort Pierce in 1925. Fleming joined the law practice of his older brother Herschal J. Dame, who was the prosecuting attorney for Saint Lucie County and the lawyer for the deputies in the Ashley Gang trial. In 1932, Flem C. Dame ran for County Judge and won in a landslide over two other candidates. He remained in this office 28 years, with no opposition, and retired in 1960. Judge and Mrs. Dame were devout and faithful members of the First Baptist Church. The men's Bible Class was named the Flem C. Dame Bible Class. He served as chairman of the Board of Deacons. Mrs. Dame taught a Young Women's Bible Class, and was active in other church activities. They supported many community projects, and Judge began a drive for a YMCA. With the accomplishment of this worthy project, the YMCA Gymnasium was named for him. He was Head Consul for the Florida Woodmen of the World and District Governor for Kiwanis. In World War II, he volunteered as an airplane observer for the duration of the war.

Fort Pierce has had the honor of having members of the legal community appointed to the Florida State Supreme Court. Elwyn Thomas, a son of the pioneer family Hal and Julia Thomas, was the first to be appointed. This began a great community pride that was perpetuated by the appointment of others in following years.

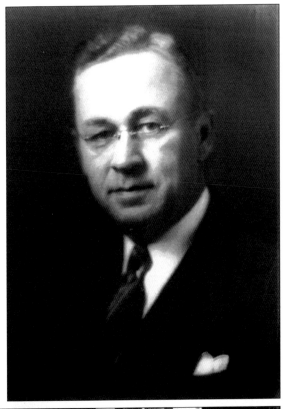

This photograph of the Florida State Supreme Court, taken in 1939, is the only known photograph of the court judges in a non-traditional business suits, instead of robes. Those presiding at that date were (left to right) as follows: Elwyn Thomas, Rivere Boford, Glenn Terrell, J.B. Whitfield, Armistead Brown, and Roy H. Chapman.

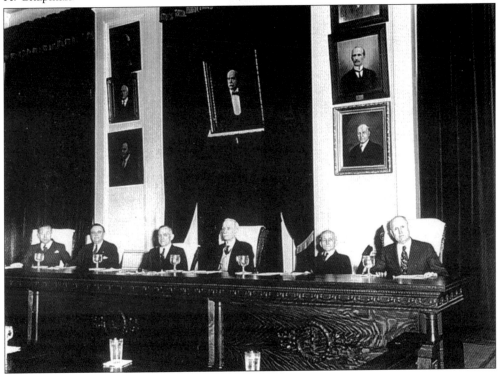

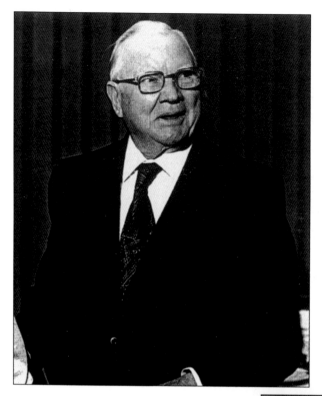

Alto Adams Sr., who had served as a Circuit Judge, was the next member from our community to be appointed to the Florida State Supreme Court Governor Cone, a Democrat, appointed Judge Adams to the Supreme Court in 1940. He served for 12 years and resigned to direct and promote family business. It was then an unusual event occurred. In 1967, Governor Kirk, of the Republican Party, appointed Judge Adams to the Florida Supreme Court, where once again he served his state. Upon his retirement, he returned to Fort Pierce where he and his family have a ranch.

James Alderman, of the pioneer W.E. Alderman Ranch family, was the next citizen from Fort Pierce to be honored by an appointment to the Florida State Supreme Court. He was appointed by Gov. Reubin Askew, in 1978, and served on the Florida State Supreme Court until his retirement in 1985. He and his wife Jennie live on their cattle ranch in Okeechobee, Florida. His grandfather, B.E. Alderman, was one of the early cattlemen, with ranches in Fort Pierce, extending into what is now Okeechobee County.

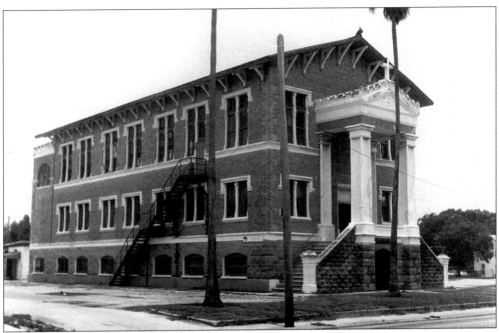

Fort Pierce, once having only a one-room school built mostly of palm fronds, now had not only a nice school on North Second Street, but also a fine school building at 10th Street and Orange Avenue, the Saint Anastasia School of the Catholic Church. A number of protestant students attended the high school classes.

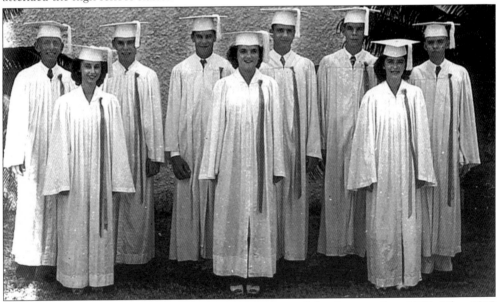

For many years, students studied at Saint Anastasia School, started c. 1912. The 1948 graduating class (from left to right) is as follows: (front row) Irene Bournival, Lanette Slay, and Theresa Vashon; (back row) Eugene Frere, Billy Wolfe, Charles Guettler, Jules Frere, Paul Guettler, and Paul Driscoll. The Catholic Church later built a new Saint Anastasia School on 33rd Street, adjacent to the new John Carroll Catholic High School on Delaware Avenue in Fort Pierce.

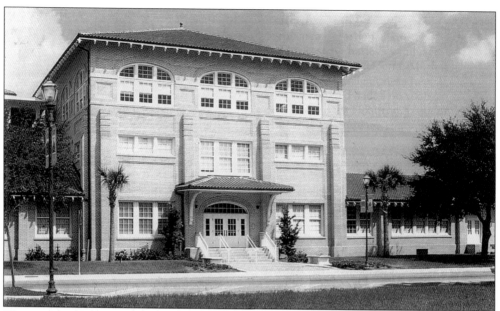

The county needed large new schools. Since this was prior to integration, two schools were built: a school on Delaware Avenue and Lincoln Park Academy, located at 1806 Avenue I in Fort Pierce. The yellow brick school is on the National Historic Register and is now a School of the Arts. It is appropriately named, for in the beginning each grade school class presented a program each year.

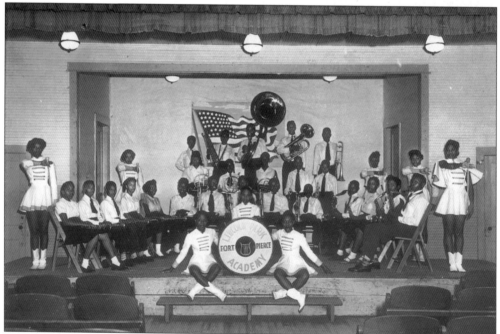

The Lincoln Park School had a master band. The school bands always marched and played in every parade or festival in Fort Pierce. This was one of the favorite bands, for the members almost danced as they marched. They inspired the parade audience to keep time to the music, almost dancing on the sidelines, and feeling merry and uplifted.

This is the girls' basketball team at the Delaware Avenue High School. From left to right, team members pictured are (front row, seated) Evelyn Rhinehardt and Lydia McCaskill; (middle row) Bernice Gallentine, Coach Swede Hellstrom, and Louise Gustafson; (back row) Ruth Brown, Estelle Gustafson, Marjorie Tylander, and Frances Buky.

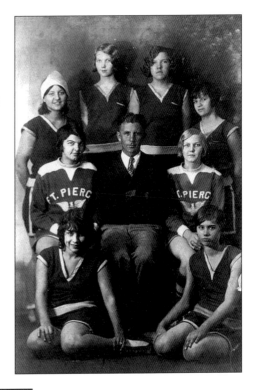

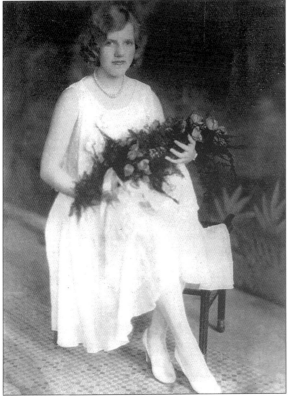

Marjorie Tylander, daughter of William Tylander, the leader of the Fort Pierce Band, is dressed for her high school graduation. Caps and gowns were not worn in those days. The young ladies wore lovely white gowns and were given a bouquet of roses to carry.

Beloved School Teacher

Miss Helen Miller came to teach math at the Delaware Avenue High School. Her students and teaching colleagues were her family, for she never married. She known as a "master gum detective," for she could detect gum in the mouth of a student even if it was not being chewed. Male students often made bets about getting through class with gum and not being detected. During World War II, she obtained the overseas addresses of her students and had a Christmas card made wishing them a Merry Christmas. She placed a stick of gum in a slot in the card that stated "For one of those I made you discard." Most of the recipients did not chew that gum. They placed it in a pocket over their heart for good luck. Many confessed that they brought it back home, and still treasured it.

Mrs. Maud Mc Combs taught music in the school. Her high school Glee Clubs presented many programs, often one of the Gilbert and Sullivan Operettas. A.E. Backus, a student who in adult years became an internationally famous artist, painted the scenery for the programs.

The Green and White Revue

OF NINETEEN TWENTY-NINE

OFFERED BY

THE BOYS' AND GIRLS' GLEE CLUBS
AND ORCHESTRA

- OF -

St. Lucie County High School

FORT PIERCE, FLORIDA

MAY 3, 1929

DIRECTED BY MAUD M. MCCOMBS

Curtain Rises At Eight O'clock

94

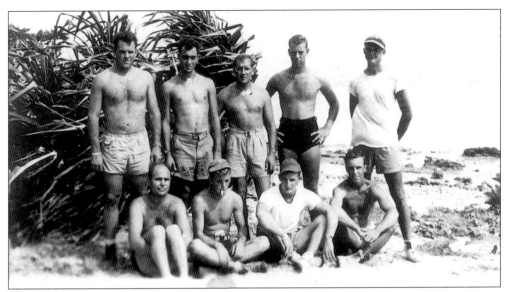

After the bombing of Pearl Harbor, Fort Pierce was immediately feeling the horror of war. Eugene Lish, who grew up in Fort Pierce, attending school in the Delaware School from kindergarten through the 12th grade, was killed in that attack. Fort Pierce once again became the site of a government base. The barrier islands were closed to civilians and became Naval Training Bases for Naval Combat and Demolition. The Underwater Demolition Team 8 members who trained at this base (left to right) are as follows: Chaplain Carp. Moretti, Ensign Calder, Ensign Hallock, Ensign Monesko; (back row) Ensign Nourse, Ensign Andrews, Lt. Commander Young, Ensign Amy, and Lieutenant Jg. Brohl

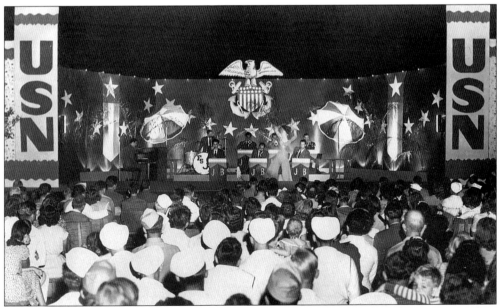

Fort Pierce opened its heart and its homes to those in the armed services who were away from their homes, training to fight the war. All prayed that others were doing the same for the Fort Pierce men and women who were training away from home. The town organized a USO Club to help entertain the service people, and many friendships were made.

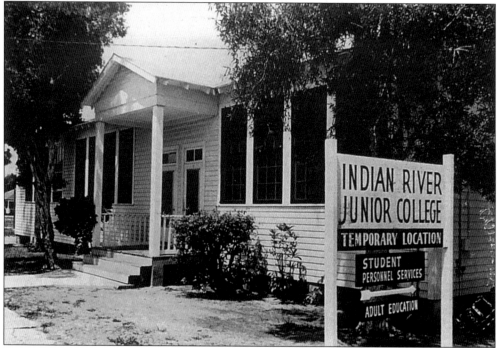

In the late 1950s, the Florida State Legislature created the Junior College Educational System. Fort Pierce was chosen as the location for the campus in the four-county district of Indian River, Saint Lucie, Martin, and Okeechobee Counties. Two colleges were established: Indian River Junior College and Lincoln Junior College. Dr. Maxwell King was chosen as president of the Indian River campus, and Mr. Leroy Floyd was chosen as the president of the Lincoln Junior College. A few buildings were moved from the abandoned Naval Base to the campus of the Delaware Ave, School, and classes were in session in 1961. Governor Collins gave the address at Dr. Maxwell King's inauguration as president.

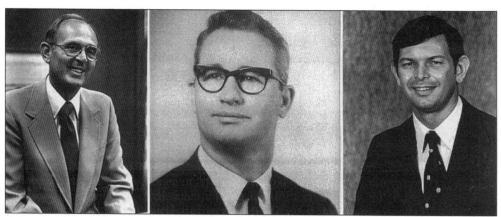

A large campus was set apart for the new campus on Virginia Avenue, and during the years three men have served the college as president: Dr. Maxwell King, the founding president in the center, from 1960 to 1968; Dr. Herman Heise, on the left, from 1968 to 1988; and Dr. Edwin Massey, on the right, from 1988 to the present.

Mr. Leroy Floyd was appointed president of the Lincoln Junior College. He, like Dr. King, had been the principal of the local high school. Each brought to his college faculty some of the outstanding teachers from the high school that had the necessary Masters Degree required for the college faculty.

Dr. George Gore Jr., president of Florida A&M University, gave the address for the inauguration of Mr. Floyd as president. In the photograph, the children of Mr. and Mrs. Floyd are in front (left to right) Carmen, Ira, and Leroy Floyd Jr. The back row, left to right, contains James Miley, Chairman of the Board of Trustees; Mrs. Floyd, President Leroy Floyd, Mr. Ben Bryan, Superintendent of Public Schools; and the inauguration speaker, Dr. Gore.

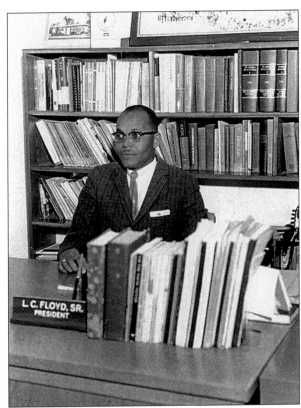

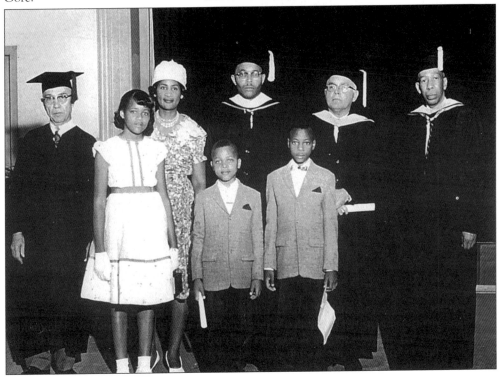

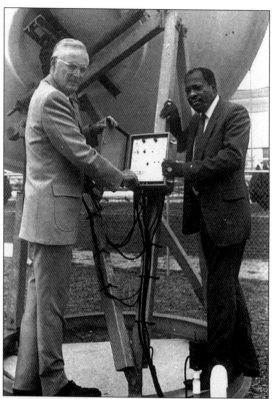

Dr. John Muir, Vice-President/Provost of the main campus, and Dr. David Anderson, Vice-President of Student Affairs, are using their manual dexterity to operate this satellite dish for National Public Radio Station WQCS on the campus of Indian River Community College.

The National Public Radio station is WQCS, on the campus of Indian River Community College. Jim Holmes is the station manager, and his able assistant is Adrienne Moore, the Public Relations and Development Specialist for WQCS. This station has won 75 state and national awards for public service and local programming.

Judge and Mrs. Alto Adams Sr. returned to Fort Pierce again upon his second retirement from serving a second time as a Florida Supreme Court Judge. Both he and Miss Cara were great supporters of educational, cultural, and church organizations. Their ranch was often used by worthy charitable organizations as a place to hold fund-raisers. They have always been great boosters for the college.

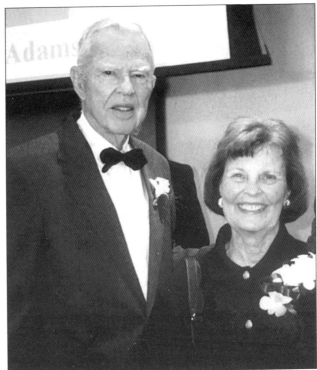

Mr. and Mrs. Alto "Bud" Adams Jr. have followed the example set by the senior Adams. Bud served on the College Foundation from 1981 until 1994, and was the president of the Foundation from 1990 until March 1994. With all of these activities and responsibilities, he had the gracious help and support of his lovely wife Dorothy. In grateful appreciation for their work, the college named the student-living dorms The Alto "Bud" Adams River Hammock.

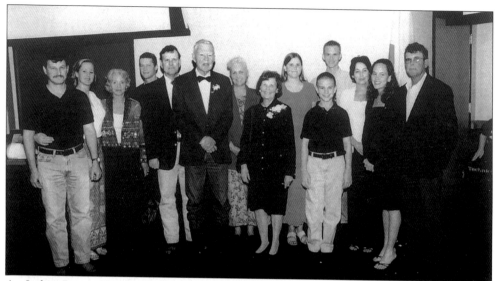

An Indian River Community College publication explains an award that has been given since the year 2000: "To promote awareness and appreciation of our free enterprise system, the Indian River Community College Foundation, Lambert Foundation, and 13 other founding members had joined together to create the Dan K. Richardson Entrepreneurship Program. Business leaders who have helped to build our community will be honored through the annual Entrepreneur of the Year Award." Past winners were Dan K. Richardson (2000), Robert L. Brackett (2001), Raymond J. Oglethorpe (2002), and Alto "Bud" Adams (2003). His family, there to enjoy the occasion with him, from left to right, are as follows: (front row) Son Robert, sister Elaine, Alto "Bud", Dorothy, Jacob, Darby, and son Lee; (back row) Cindie, John, son Mike, Rachael, Caitlin, Caleb, and Cynthia.

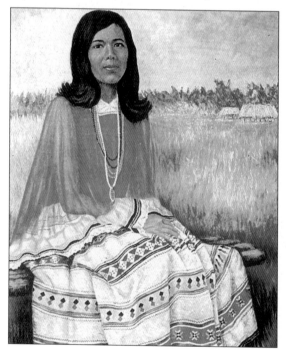

Each year five community college graduates in the state of Florida are chosen for the Leroy Collins Award, named for the former Governor LeRoy Collins, under whose administration the Community College was created. Louise Jones Gopher, an Indian River Community College and Florida Atlantic University Graduate, who was the first Seminole woman in the history of her nation to earn a college degree, was one of the winners. She returned to the reservation and has spent her time and knowledge working with the youth on the Florida Reservations to encourage them to get a good education, and to honor and preserve their heritage.

The college offers many cultural courses that regular students, adult tourists, and retirees enjoy studying. Helen Terry has been affiliated with the college for many years teaching art classes. She paints portraits for many, and is also a poet who combines her two artistic gifts to publish illustrated cards and note paper. One of the churches in town has a collection of life-size paintings of the Disciples that she painted, using men as models whose personalities seemed appropriate for the different followers of Christ

The Hallstrom Planetarium presents programs for day and night for students as well as citizens. The courses are interesting, and the programs are entertaining as well as educational. The planetarium was named for Axel Hallstrom who was a dedicated supporter of the college. This facility has programs planned and produced by, Professor Jon Bell, director of Hallstrom Planetarium.

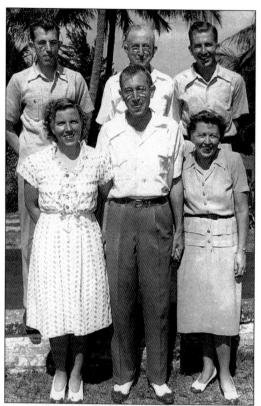

Much of the strength and spirit of Fort Pierce is a result of the families who now have roots that extend five and six generations deep. This creates a sense of family among the citizens that is stronger than friendship. One such family is that of William Tylander who led the town band back in 1905. From left to right are (front row) Marjorie T. Willes, William H. Tylander, and Elizabeth T. Arnold; (back row) Raymond Tylander, Father William E. Tylander, and Robert Tylander.

The Tyler family is another of many generations to remain here. Their pioneer ancestor, Frank Tyler, maintained one of the first large hotels on the coast. The two boys on the front are Thomas on the left and Clifford on the right. On the back row, from left to right, are Bill Robinson, Louise Tyler (wife of Frank), Jack Taylor back of Louise, Tillie Sullivan, Edith Sullivan, Ethel Tyler Robinson, Mrs. F.M. Tyler, Margaret Tyler Taylor, and Mr. F.M. Tyler.

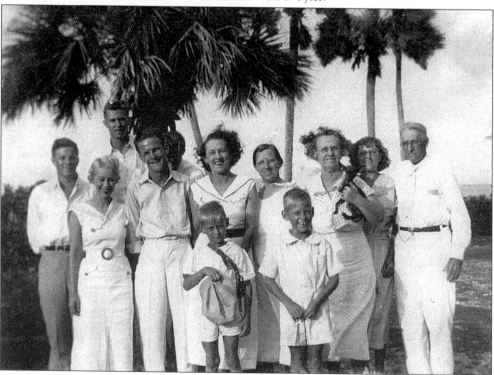

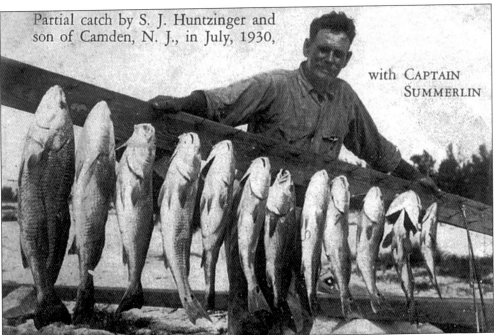

Partial catch by S. J. Huntzinger and son of Camden, N. J., in July, 1930, with CAPTAIN SUMMERLIN

As one can see, the early fishermen did not fish the Indian River Lagoon dry. Fishing is still a good business and a pleasant sport. The Summerlin gentlemen still make good hunting and fishing guides.

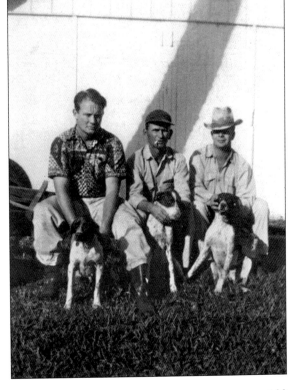

Fort Pierce has many stores and shopping malls that supply groceries. However, sportsmen and the local men still enjoy the hunt. These three men are all from those early pioneer families who needed to hunt to put food on the table. The men, with their bird dogs ready to for the quail hunt (from left to right) are as follows: Harold Williams of the early citrus family, Jay Albritton, from pioneer cattle folk, and Karl Carlton, grandson of the first cattleman to come to the area.

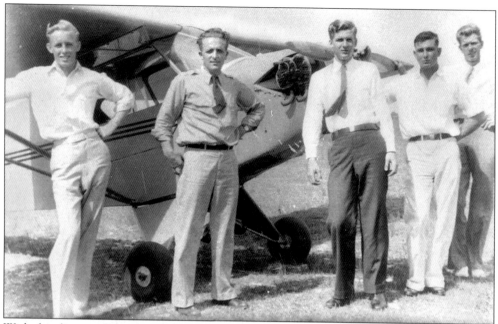

With the climate of Florida supplies, many learn to fly. These young men, after achieving that goal (from left to right) are as follows: Sidney Brewer, Clay Weaver, Howard Brown, Quillie Hazellief, and an unidentified friend.

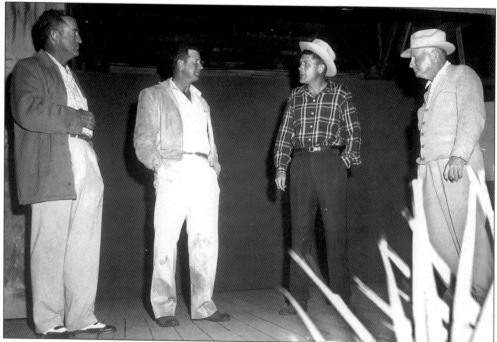

These four gentlemen have come to the platform of the Farmer's Market to rehearse a scene in the historical outdoor drama, *Along These Waters*. In their roles, each is portraying his pioneer father or grandfather, from left to right, Brian McCarty, Rueben Carlton, John Moose, and "Buck" Hendry.

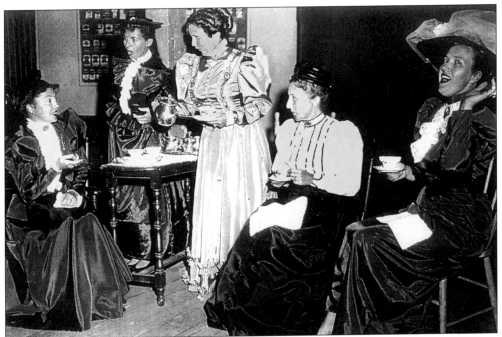

The ladies, portraying their pioneer ancestors, (some even wearing the original clothes) from left to right, are as follows: Joan Raulerson Sloan, Lace Vitunic, Janiece Sumner, Geraldine Brown Bryan, and Edith Mullins. Each year these women enjoyed the opportunity to portray the lives of these pioneer ladies in the local outdoor drama, *Along These Waters*.

Some members of the cast were relaxing on the stage set of the Carlton Brothers' Buckhorn Saloon in the outdoor drama. The ladies in front, from left to right, are as follows: an unidentified lady, Joan Carlton Humphries and Robyn C. Wright (leading ladies on alternate nights). The gentlemen are the following: Wayne Carlton, M. Cully, Don Mullins, and Mike McCarty.

The cast in this scene of the historical outdoor drama are, left to right, as follows: Bill Jones, as the Seminole Chief Wild Cat; Romantic leads, Joan Humphries and Don Mullins; and O.L. Peacock Jr., as Colonel Pierce, in command of the U.S. Fort Pierce along the Indian River during the Seminole Wars.

In another scene from *Along These Waters*, Ben Frombach portrays the pioneer barber, Billy Whistle-Britches. History tells that when a person passed by with a good catch of fish, Billy would always leave his half-shaved or half-a-haircut customer, telling them that he had to go catch the fish while they were biting. He always assured his patrons that they did not have to pay for what he had done for them. The other cast members from this scene are the irate customer, Lyle McGlen, and the boy, Bert Jones.

106

Rueben Carlton II was named for his pioneer grandfather who not only brought the first cattle but also the first school teacher to Fort Pierce. He became a cattleman, citrus grower, and also a pilot. He served in World War II, and was one of the pilots chosen to fly bombers over Japan. After the war, he used an airplane to use to check his cattle and his citrus groves. There are seven generations of the Carlton family still living in town, and still using some of the land of their ancestors.

Harold S. Williams, a descendant of the first commercial citrus growers, and Rueben Carlton rode on the same bus to school each day. They both lived with their pioneer parents west of town on big ranches and groves. Harold learned to fly before World War II, joining the Air Force during the war, where he was trained as a fighter pilot. After the war, he bought one of the Stearman planes sold by the army. He bought more planes and also a helicopter to use in his Agriculture Air Service. In 1948, his airport was licensed, allowing him to operate an Agriculture Air Service for 56 years, along with his business of citrus growing.

In 1952, Dan McCarty was elected governor of Florida. The grandson of C.T. McCarty, a pioneer attorney who later became a large pineapple grower, Governor McCarty was educated in Fort Pierce schools and the University of Florida. He was a citrus grower and rancher, and was married to a local woman, Olie Brown. This is a portrait of Fort Pierce's First Lady of Florida: the beautiful and gracious Olie Brown McCarty.

Dan McCarty was elected governor after having served in the State Legislature. This photograph shows his inauguration speech in Tallahassee. Tragically, he died during his first year in office. This was a fate he shared with another governor of Florida, Ossian B. Hart, who at one time had lived in the Fort Pierce area. Hart came to the area due to the Armed Occupation Act, an act that gave persons the privilege of homesteading 160 acres of land if they remained or seven years. His group fled the area after only four years because of conflict with Native Americans. Hart was elected governor in 1873 and died his first year in office.

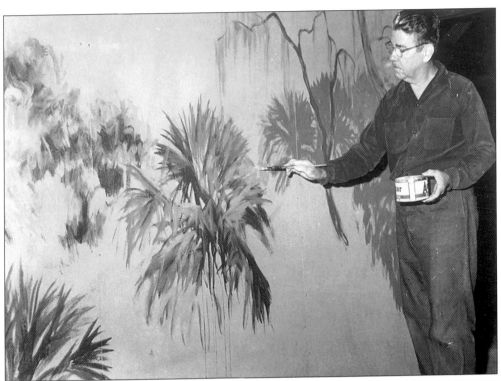

A.E. "Bean" Backus was born with a gift for art. He loved the area, his home since birth, and delighted in painting the land, in many moods, especially the sky. He painted posters for movie theaters and stage sets for school plays and concerts. He studied art in his adult years, and then invited talented young students into his studio for lessons—refusing to be compensated for the lessons. His reputation grew, and he was recognized internationally as a great landscape artist. In this photograph he is painting scenery for the annually produced outdoor drama.

Olive Dame Peterson, a lifelong friend of Backus, wrote a biography of him that was greatly appreciated by his fans. An educator, actress, arts patron, and historian. She served as the chairman of the Saint Lucie County Historical Commission, is an active member of the County Historical Society, and served as president of the Florida State Historical Society. Recently, she wrote another book about Backus. In addition to the biographical text, she included color copies of many of his painting of Florida waters, back country, and plants, trees, and flowers native to this area.

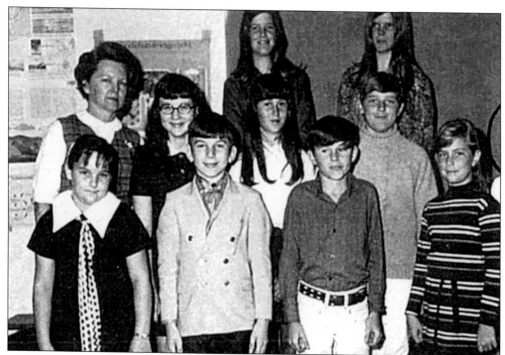

A small private secular school was established by those who desired a smaller student ration per class. The Indian River Academy attracted a number of recently retired public school teachers. One such teacher, Mrs. Arleen Hanson Coats, served as the advisor for the Student Council, later becoming the Head Mistress of the school. Council members, left to right, are as follows: (front row) Brenda Hamilton, Sid Gilbert, Mark Moser, and Michelle Beranek; (middle row) Advisor Mrs. Coats, Susan Gilbert, Lisa Albritton, and Richard Modine; (back row) Beth Pye, Secretary; Brenda Pye, President. Absent: Joe Beedy and Dee Dee McManus.

Indian River Academy had a large Glee Club with an excellent reputation, under the direction of Mrs. Shelley Evans. Here are some of the new members accepted into the Glee Club, obviously beaming with pride and happiness, left to right, are as follows: (front row) Jimmy Shreckengost, Mike Shaw, and Jeff Williams; (back row) Steve Shaw, Gary Hockett, Lane Hockett, and Anita Costopoulos.

After World War II, many servicemen previously stationed in Florida returned to make their home. Doug and Marge Silver had been winter visitors to Fort Pierce prior to his term in the Navy, stationed in Miami. They established the first radio station, WIRA, and hired Miss Ann Wilder as the newscaster. Marjory and Fort Pierce Business Manager Gustafson posed for this sign directing the public to WIRA, located on Melody Lane. Mrs. Silver was the first woman elected to the County Commission in Saint Lucie County.

John and Carolyn Jones are among those who have been in this area for six generations. John is a descendant of one of the first five pioneers, James Paine. Paine fought at Fort Capron in the third Seminole War, and was given a land grant by the government. One of his daughters married Judge Miner Jones, grandfather of John. Each generation has continued to live on that same land owned by their ancestors. John and Carolyn, who celebrated their 50th wedding anniversary, maintain their home on that land. Their son and his family as well as their daughter and her family also maintain residences on the land.

Dr. Clem C. Benton, physician, humanitarian, and entrepreneur was the first African-American physician in Fort Pierce. His many accomplishments include the following: founding father of the Fort Pierce Memorial Hospital, volunteer of medical services to the Saint Lucie County Health Department, member of the Fact Finding Committee to establish Lawnwood Medical Center, trustee of Indian River Community College, provider of housing development for the needy, and many more philanthropic services

The new Federal HRS Building in Fort Pierce has been named the Dr. Clem C. Benton Building, dedicated on October 20, 1995. Dr. Benton is survived by his children Clem C. Benton Jr., Arlena Benton Lee, and Margaret A. Benton.

The Treasure Coast Opera Society's production of *La Traviata* is seen here on January 18, 2003 at the St. Lucie County Civic Center in Fort Pierce. Heather Sarris (left) played "Violetta" and Linda Mule (right) played "Flora." The TCOS chorus, composed of local singers, are (left to right) Yvonne Gagne, Christine Hill, Joy Bernardo, Eleanor Sweeney, Maria Santovenia, and Richard Schultz.

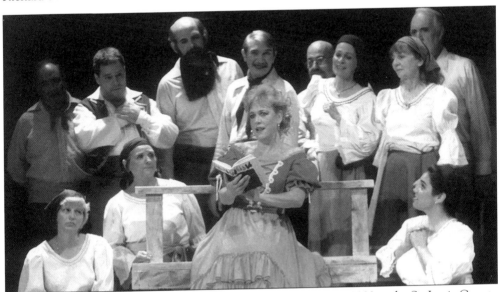

The TCOS production of *L'Elisir D'Amore* is seen on February 22, 2003 at the St. Lucie County Civic Center in Fort Pierce. With "Adina," sung by soprano Victoria Atwater, are members of the TCOS chorus. From left to right they are (front row) Katrina Houser, Sandra Childress, and Joanne Martinez; (back row) Richard Estevez, Peter Buchi ("Nemorino"), Tom Williamson, John Organ, Milo Eischens, Diana Alvarez, Charmian Herd, and Duane Sisson.

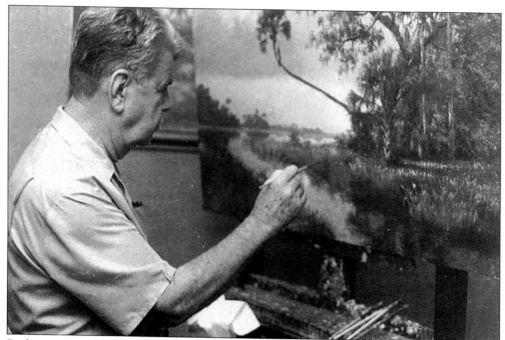

Backus paints a landscape before he became an internationally well-known artist. Lyndon Johnson obtained one of his paintings. They later began to appear in many offices of United States Senators and Congressmen. He had orders a year in advance. Prices rose into the thousands, yet he gave many organizations free paintings for auction and fund-raisers.

A.E. "Bean" Backus Gallery & Museum

™
A.E.Backus

The Art Club wanted to name the Art Gallery for A.E. "Bean" Backus, but he refused to allow it. After his death, his hometown quickly had the gallery named for this talented, generous, beloved pioneer son.

In 1995 Fort Pierce, the seat of Saint Lucie County, celebrated the 150th year of statehood for Florida and the 90th year of the creation of Saint Lucie County by replicating the parade that was held in 1905. The representative from the Saint Lucie County Historical Commission, Cynthia Putnam Crankshaw, who served on the parade committee, asked Hal Williams, grandson of the 1905 Parade Marshall Lee Coats, to portray his grandfather as the Marshall of the anniversary parade. Dressed with red, white, and blue ribbons across his chest, a plume in his hat, and red, white, and blue flowers and a flag on the front of the saddle, he looked just as his grandfather had. He rode like a natural, having spent many hours riding at his Uncle Turner Coats' Flying T. Stables.

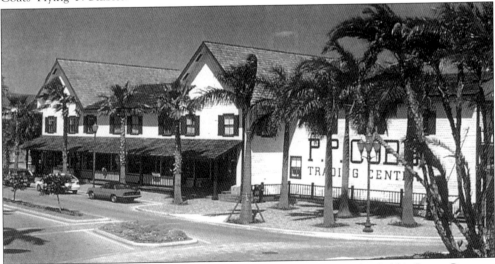

The parade followed the same route as the original in 1905, passing by Cobb's Store. Compare this photo of the store with that in the photograph of the original parade. Modern beautification enhances the appearance of the building.

Zora Neale Hurston, a native Floridian, was noticed as a bright young lady by those in the community who provided her with a scholarship to a college. She later became a renowned novelist, the most famous African-American novelist to date. In her elder years she came to Fort Pierce to be a journalist for the newspaper. She was a substitute teacher at the Lincoln Park Academy, became friends with local ladies who enjoyed meeting to discuss art and literature. She died in Fort Pierce. A new library was named for her, and many researchers have come to learn more about her life. The Post Office issued this stamp to honor her.

A check for $2,000 was presented to Saint Lucie County Commissioner John B. Park to help pay for a piano for the new Civic Auditorium on Virginia Avenue. This represented the profit from the Saint Lucie County Bicentennial Committee production of *Along These Waters*. From left to right, persons are as follows: Dwight DeBolt, chairman; Commissioner Park; Hal Roberts, vice-chairman of the committee; and Bill Ezell, Committee treasurer.

— St. Lucie County Marine Center —
— Featuring The Smithsonian Marine Ecosystems Exhibit —

Fort Pierce is located along the shores of one of the most biologically diverse marine environments in the continental United States, the Indian River Lagoon. For this reason, the area was chosen for marine projects and institutions. It is here that marine scientists from all over the world come to research and lecture. This marine center moved here from the Smithsonian's National Museum of Natural History in Washington, D.C.

The Harbor Branch Oceanographic Institution, providing underwater vessels for scientific observation and study of marine life and plants, is another marine organization that produces classes and speeches, as well as tours for students, scientists, and tourists.

This Manatee Center gives the opportunity to observe this sea mammal, and to attend lectures about their survival.

The Seven Gables Information and Visitor Center welcomes all who need directions and information about Fort Pierce and Saint Lucie County. It is early Florida architecture, once the home of a popular coach and educator, Larry Slay, whose father always said, "I have a home with seven gables, and a pretty daughter to go in each one."

This aerial view of the Saint Lucie County Historical Museum shows that it, too, is located near the river. It is on the barrier island, South Hutchinson Island, east of the mainland. The museum building is a replica of the early Florida East Coast Railway Station. The home on the right of the museum is furnished as the homes in the 1800s were, even with the "out house" used before the advent of the indoor bathroom.

Dane Jeffrey Williams is another descendent of the pioneer families who continue to live in Fort Pierce. He is a sixth generation from the founders of The Allapatahatchee Fruit and Vegetable Co. who started the first commercial citrus groves. He is an excellent student, recipient of the Sons of the American Revolution Citizenship Award, and is an avid fisherman who had a private lake named for him, Lake Dane.

Historic downtown Fort Pierce is being maintained by the many families who are of the sixth and seventh generations. It also pleases the newcomers. This scene is Second Street, once called Pine Street. It was shown in the 1800s as a dirt road covered with oyster shells. The improvement would please the local officials' forebears.

The new County Main Library is shown in the background, located in Fort Pierce in the neighborhood of Cobb's Store, Avenue A, and the Indian River. The palm trees and fountain add to the physical beauty of this building that enhances the mind.

The Heathcote Botanical Gardens, voted the "Best Picture Spot in the Treasure Coast," is visited by gardeners and school children on field trips. It is the setting for weddings, garden club meetings, and plant sales. One garden clubs that meets here is devoted solely to the growing native plants. This was once a privately owned commercial nursery for sale. Through the leadership of Gloria Moore and the numerous garden clubs and local citizens represented, the commissions purchased the property. The botanical gardens are constantly being enlarged, and are visited by organizations and individuals from many communities. This place is truly a treasure of beauty for the entire Treasure Coast to visit.

Prior to the modern development of the Indian River Drive in Fort Pierce, The Night Blooming Cereus vines grew on many palm trees along the drive. During their season of blooming, which occurred at night, citizens would take the time to travel down the River Drive to view the white blossoms in the moonlight. This photo was taken at night with the aid of car lights. The Heathcote Botanical Gardens now makes available such lovely scenes as this.

121

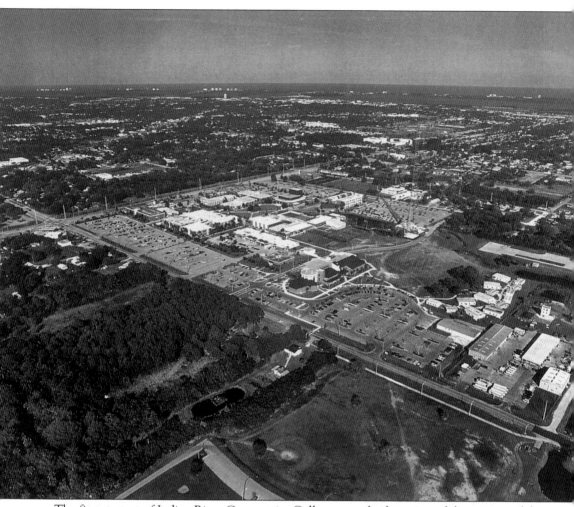

The first campus of Indian River Community College was a back section of the campus of the County Yellow Brick School on Delaware Avenue. Administration and classes were held in a single wooden structure brought over from the World War II Navy Base. It was the only campus in the four county college district. This aerial view shows the main campus today, 2003. There are campuses in each county, Main Campus, Fort Pierce; Chastain Campus, Stuart; Dixon-Hendry Campus, Okeechobee; Mueller Campus, Vero Beach; IRCC/FAU Campus, Saint Lucie West; PSL, and the newest, in Martin County, is The Indian Town Education Center, in Indian Town, Florida. Additional facilities are the Indian River Academy and the Strelsa Schreiber Classroom Building. The college has developed a statewide and national reputation for excellence, establishing a record of top performance in the state on the College Level Academic Skills Test, and in 1993, the Tech/ Prep Program was named number one in the nation. The three presidents, Dr. Maxwell King, Dr. Herman Heise, and Dr. Edwin Massey, have led this institution well, and the prestigious academic record of this institution honors them, their faculty, and staff.

When the county was created, the editor of the paper used this photograph of the baby daughter of Clarence and Mary Summerlin, maintaining that the county, like little Adelaide, was new and eager to grow. The only trouble was that Adelaide, at that time, was then a seven years old girl and was embarrassed to have her friends should see her undressed and sitting in a bowl. She grew up to be a teacher who taught United States History to several generations of high school students. Her teaching showed students the facts but also stirred a deep sense of patriotism within them.

These students of the Indian River Academy Patrol had an important responsibility for the safety of their fellow students. The students (from left to right) are as follows: (front row) Mike Franklin, Mike Roser, Debbie Beedy, Kathy Lollis, and Kathy Applebee; (middle row) Kathy Sapp, Ricky Modine, George Rowe, Jean Patrick, and Chuck Rappold; (back row) Advisor Mr. Gerrish, Mary Phillips, Cindy Hayes, Beth Pye, Pam Williams, Kathy Tracey, and Barbara Askins.

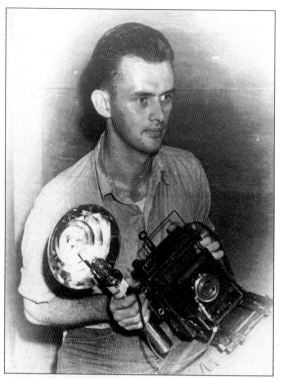

Leon "Jim" Heffelfinger was a United States Navy Photographer. For years he has served as the photograph curator of the Saint Lucie County Historical Museum.

During the Florida Land Boom, Fred G. McMullen, president of the Fort Pierce Bank, organized the Fort Pierce Finance and Construction Company for the development of a port at Fort Pierce in 1921. The land boom burst and the Depression took over in 1927. Edwin Binney invested heavily in the company and became president. He brought money to the Fort Pierce bank and kept it from closing. By 1930 the port awaited the arrival of its first ship. Today it is owned and run by the King Maritime Group LLC.

On December 17, 1983, The Pineapple Players Community Theatre reached the financial stability to purchase this building to renovate as a theatre. At last they had their own auditorium for rehearsals and shows, their place to store costumes, props, and stage sets. Wilma Cowles was the great mover for the two community theaters in Fort Pierce, first, the Dolphin Players, and later The St. Lucie Players.

Associate Professor of Astronomy Jon Bell, director of the Hallstrom Planetarium at Indian River Community College, teaches many citizens who are not students. He has given lessons on how to use a telescope. Many buy telescopes due to the closeness in proximity of the location to the Kennedy Missile Base. Bell says, "My job is to get people to look up!" That is what people do when they attend the exciting programs at the planetarium. They enjoy the thrill of the majesty of the universe.

IRCC's astronomer Bell:

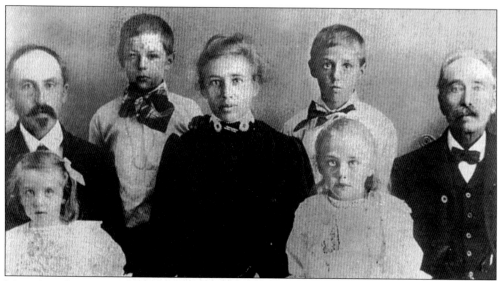

Many Scandinavian families came to Fort Pierce in answer to a magazine ad telling of the cheap cost of land. They stayed at the Tyler Hotel and went out with a man who said he represented a land company. Each chose the land he wanted, and paid a down payment. The contracts were to be given to them the next day. The man disappeared with their money, and there was no such land company. Despite their loss, these people stayed, worked, were given credit by Peter Cobb at his store, and given weekly payments by Henry Flagler to help them get started. They became fine citizens, established homes, groves, farms, and businesses. Their descendants have names such as Hansen, Jorgensen, Helseth, and Christiansen. This 1905 photo of the Hansen family includes, from left to right, (front row) Elsa Hansen and Karen Hansen; (back row) Reg. Hansen, Peter Hansen, Mother Sissa Hansen, Paul Hansen, and Grandfather Hansen.

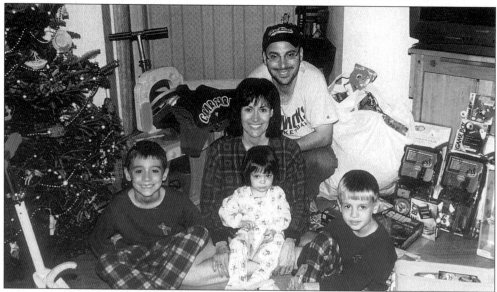

Celebrating Christmas in 2002 are a sixth generation of pioneers who, like other pioneer families, have been celebrating Christmas each year in Fort Pierce since the 1800s. The children are, left to right, Dylan, Katie, and Jon, with their parents Beth and David Farinacci. Little Katie was named for the pioneer teacher, Miss Katie Turner, her great-great grandmother.

126

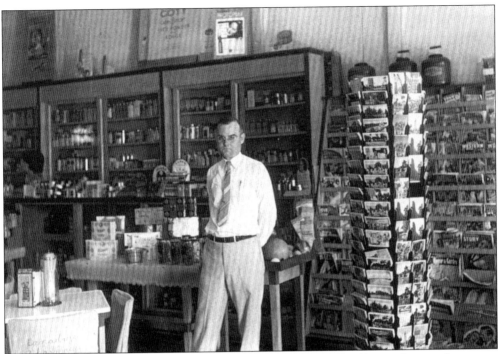

The Arcade Building of 1926 was the most modern building in Fort Pierce. It was a forerunner of the present malls, for it had a wide hall in the middle with shops on either side, as well as the outside walls facing the sidewalks and street. It also contained an upstairs with professional offices. In 1928, Eddie Canaday opened a pharmacy. Canaday awaits his hometown customers.

These customers are enjoying the soda fountain in Canaday's Pharmacy. Seated at the counter, from back to front, are an unidentified man, Pat Thompson, Isabelle Osteen, and Judy Canaday. When Ed Canaday and Pearl, his wife, retired, the grown Judy and her husband John Wetmore ran the business. Isabelle Osteen grew up to own a very nice dress shop in town.

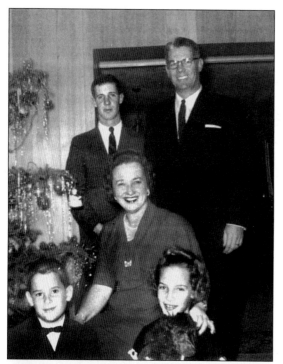

John McCarty is the grandson of pioneer C.T. McCarty, an attorney who became one of the largest pineapple growers in the area. John, also an attorney, is shown with his family. Pictured from left to right are (front row) son Tommy, mother Louise, and daughter Peggy, with her puppy; (back row) son Johnny and Senator McCarty. John and Louise felt that "The family members were active partners in their most important project, building and keeping a warm, close, happy life together." John and Louise were active in Saint Andrews Episcopal Church of Fort Pierce, the church his parents helped to found. John helped his brother Dan in his election as Governor, and John was elected a Florida State Senator, representing the area.

These two pioneers are Mr. M. Traynor and young Andrew Jorgensen, an early Scandinavian pioneer. Anna Marie Jorgensen took the position of a nurse and was a blessing to the ladies of town when Dr. Platts was called out of town and a baby needed to be delivered. Another of this family, Nils Jorgensen, was elected a county commissioner for numerous terms. N.W. "Bill" Jorgensen served many years as a county commissioner. The spirit of pride and caring of these many families who have lived here for six and seven generations creates the kind of environment in which one would like to live and rear children.